C000102397

— The Men Who Built —

LOUISVILLE

— The Men Who Built —

LOUISVILLE

The City of Progress in the Gilded Age

Bryan S. Bush

THE
History
PRESS

Published by The History Press
Charleston, SC
www.historypress.com

Copyright © 2019 by Bryan S. Bush
All rights reserved

Cover images: A bird's-eye view of Louisville. *Library of Congress; from left to right*: George Frantz Sr., Dennis Long and H. Victor Newcomb.

First published 2019

Manufactured in the United States

ISBN 9781467141253

Library of Congress Control Number: 2018960977

Notice: The information in this book is true and complete to the best of our knowledge. It is offered without guarantee on the part of the author or The History Press. The author and The History Press disclaim all liability in connection with the use of this book.

All rights reserved. No part of this book may be reproduced or transmitted in any form whatsoever without prior written permission from the publisher except in the case of brief quotations embodied in critical articles and reviews.

CONTENTS

CONTENTS

ACKNOWLEDGEMENTS

I would like to thank the Louisville Free Public Library for allowing me access to its research tools. I would not have been able to complete the book without its website and books.

I would like to thank Cave Hill Cemetery in Louisville, Kentucky, for its support throughout the years and in particular Michael Higgs, coordinator of the Cave Hill Heritage Foundation. Cave Hill Cemetery is Louisville's premier cemetery. The purpose of the Cave Hill Heritage Foundation is to secure funding for the long-term preservation of this unique cemetery. Specifically, the mission of the Cave Hill Heritage Foundation is threefold:

- TO RESTORE THE HISTORICAL MONUMENTS AND BUILDINGS. Cave Hill Cemetery is known for its exquisite collection of monumental art, many examples of which are more than 150 years old. Additionally, the property includes a variety of historic structures, from the administration office to the boardroom to the three-and-a-half-foot wall of brick and stone that encircles the perimeter. The resources provided through the foundation will allow cemetery management to be proactive both in addressing specific, long-term conservation projects and in responding to critical situations that require immediate stabilization and intervention.

- TO PRESERVE THE ARBORETUM SETTING. On average, fifty trees are removed each year at Cave Hill Cemetery due to disease,

old age or weather damage, and more than one hundred plants are replaced. The Cave Hill Heritage Foundation will help provide resources for the unexpected, as well as help preserve and sustain the beauty of the cemetery's arboretum setting. It will provide for the removal and replacement of specimen trees and shrubs to ensure that future generations will have access to this amazing green space in the heart of Louisville.

- To provide community education and awareness. The history of Cave Hill Cemetery is inextricably tied to the history of Louisville. Through its landscape and monuments, the cemetery tells the story of this beloved city by the river and its remarkable citizenry. The Cave Hill Heritage Foundation will help provide resources to produce educational materials, expand public awareness and develop special events and programs for schoolchildren and the community at large. It will also ensure that the critical task of recording and archiving the history of the cemetery will continue.

I would also like to thank my parents, Carol and Gene Bush, and my stepmom, Joan Bush, for their support.

INTRODUCTION

The Gilded Age ran from about 1870 to 1900. The name was coined in Mark Twain's book *The Gilded Age: A Tale of Today*, which satirized an era of social problems in the United States masked by a thin gold lining. The title came from Shakespeare's *The Life and Death of King John*, in which the king is dissuaded from a second superfluous coronation with the argument: "To gild refined gold, to paint the lily…is wasteful and ridiculous excess." The American Industrial Revolution, which occurred between 1865 and 1901, transformed the United States from a country of small and isolated communities into a compact economic and industrial unit. The Gilded Age was a period of rapid economic growth. Immigrants came to America seeking higher wages than Europe could provide, and with the readily available labor force, there was a rapid expansion of industrialization.[1] The Gilded Age was also a period of massive poverty and inequality, and only the select few had a high concentration of wealth. From 1860 to 1900, the wealthiest 2 percent of the American population owned more than one-third of the nation's wealth, while the top 10 percent owned three-fourths of the money. The bottom 40 percent of the population owned virtually no wealth at all.

During the Gilded Age, railroads were the new industrial economy. Railroads made possible the development of new areas of commerce, as well as the factory system, mining and finance. The American Industrial Revolution depended on the ability to move raw materials, agricultural produce and manufactured articles quickly from production sites to cities,

and railroads made that possible. During the Gilded Age, there was also a rapid development of the West in farming, mining and ranching. Industrial growth and westward expansion were ensured by the revolution in transportation and communications. During the 1870s and 1880s, the United States economy rose at the fastest rate in the country's history, with real wages, wealth, gross national product and capital formation all increased. Transportation and communication forms were expanded, and new forms were created. Railroad lines expanded across the country, and new systems such as streetcar networks rose in large industrial cities. Telegraph lines gave way to the telephone, and gaslights gave way to electricity and the incandescent lightbulb.[2]

To power the manufactories, raw material was needed. The United States had two-thirds of the world's coal, iron ore, petroleum and, in the West, gold, silver and copper. Kentucky already had rich resources in coal and timber to keep the factories running.

America needed manpower to fuel the Industrial Revolution during the Gilded Age, and there was an explosion in population, from 35,701,000 in 1865 to 77,584,000 in 1901. Immigration also helped with the need for labor. In 1890, 56 percent of the labor force in manufacturing and mechanical industries was of foreign birth or foreign parentage. Between 1865 and 1900, employees in manufacturing increased from 1,300,000 to 4,500,000, and factories built during this time period rose from 140,000 to 512,000.[3] The agricultural revolution during the Gilded Age hastened the Industrial Revolution. An increase in production per farmer allowed a transfer of labor from the field to the factory without reducing the country's food supply. New inventions and improved technology transformed the farm. New methods of farming, inventions in equipment and artificial fertilizers all helped to increase food production. The profit from agriculture could be used to buy manufactured goods and continue to stimulate the industrial and manufacturing revolutions.

Wealthy industrialists and financiers built the core of the American industrial economy, and these men helped expand the nonprofit sector through acts of philanthropy. Private money flowed into museums, hospitals, colleges, academies, schools, opera houses, public libraries and charities. During the Gilded Age, Louisville became an important city in industry, trade and commerce, following the national trend. Louisville experienced the introduction of new railroads, the extension of the old ones, the bridging of the Ohio River, the improvement of the Portland canal and of river navigation, the introduction of modern methods to every sector of business

life and the erection of buildings devoted to commerce, manufacture and domestic purposes.[4] To help fund the massive expansion of commerce, trade, manufactories and industries, Louisville saw an increase in banks to help fund the new projects, and with the growth of those banks, Louisville saw the rise of wealthy financiers.

Feeding Louisville's massive explosion in factories and industrial centers required coal, coke and natural gas, which were provided by the mining industry. Railroads brought in the raw materials to power the plants and manufacture the products. Once the product was completed, the rivers and railroads were ready transportation methods. With railroads, Louisville could ship its completed products from the East Coast to the West Coast as well as north and south.

Louisville had a massive influx of Irish, German and other immigrants who flowed into the city and contributed to the available workforce. Former slaves who fled the South in search of a new home found jobs in Louisville in the rising industrial tide. Former Confederate soldiers leaving the devastated South also came to Louisville for a new life. Street railways helped workers find new housing outside the city limits and brought the workers into the workforce more easily.

The wealthiest industrialists and financiers helped build the Louisville Park System without government money. They helped found the Louisville Scientific and Industrial School and helped fund the Speed Art Museum. With wealthy citizens, Louisville could afford art and support local artists.

Louisville's top products in industry, trade and commerce were tobacco, whiskey bourbon and plows. To feed the South's and West's needs for new technology in farming, Louisville became the largest manufacture of plows in the world. To help build the new infrastructure, the country needed cement. Louisville provided the best cement in the country. New infrastructure also needed pipes, and Louisville became the nation's leader in producing cast-iron pipes for water and sewers. The city also led the country in jeans and wool cloth. Louisville produced, raised or made wagons, valises, trunks, chocolate, boilers, tinware, shoes, pork, lumber, newspaper and wrapping paper. Three large plants in Louisville were involved in artificial fertilizers. Paints, colors and varnishes formed a large and rapidly increasing industry. Millwrighting, copper and brass work and wire works were also growing industries. Louisville produced pickles and cider vinegar, chewing gum, patent medicines, plumber's supplies, brooms, monuments, stonework, vitrified brick, firebrick, paving materials, terra cotta, clay sewer pipe, electrical and surgical instruments, steel and wood singletrees and neck yokes. All of

these were thriving industries in Louisville. About one thousand people were involved in the publishing, lithographing, binding, electrotyping, stationery manufacturing and paper boxes businesses.

While the first part of this book addresses the general history of Louisville in this era, the second part examines the men who helped build the city of progress. Many were self-made men. With their accumulated wealth, the men of the Gilded Age gave their money to schools, charities, museums, parks and other philanthropic endeavors. Chapters will cover such industrialists as Dennis Long, who was the largest provider of cast-iron pipe in the nation; Benjamin Avery, who was the largest manufacturer of plows in the country; James Breckinridge Speed, who was president of the Louisville Cement Company and helped provide telephone service to the city; Andrew Graham, who held the record for the sale of the most hogsheads of tobacco in the history of the country and helped put Louisville on the map for the tobacco trade; John Morton, who was in the publishing industry and supplied schoolbooks to the South; Frank Menne, who owned the largest chocolate factory in the state of Kentucky; James T. Wilder, who was the largest druggist in the United States; the Frantz family, who provided leather; and John Leathers, who was in the jean cloth industry.

As you read about the men who were important figures in the Gilded Age in Louisville, you will learn that many did not come from privileged backgrounds or have college educations. Many of them were not originally from Louisville or even were immigrants. Many of them succeeded in their original profession that made them wealthy, but to increase their wealth, they branched out to other industries and finance, becoming directors of railroads, banks and other institutions and contributing to the improvement of the city.

The Gilded Age in Louisville

The end of the Civil War opened up the Southern states to the markets along the border, and Louisville became the center of trade and commerce. Trade and industry had a vigorous and successful start, and the city became prosperous. New railroads, the extension of the old ones, the bridging of the Ohio River, the improvement of the Portland canal and of river navigation, the introduction of modern methods in every sector of business life and the erection of buildings devoted to commerce, manufacturers and domestic purposes were all contributing factors to Louisville becoming an industrial city.[5] After the Civil War, former slaves and their families flocked to Louisville and helped provide a ready source of manpower. Foreign immigrants found opportunities in the new industrial city. Ex-Confederate soldiers took advantage of the opportunities in the thriving commerce center that was undamaged by the war and was not under a military government and found a community that embraced them and their "Lost Cause." Most of these men went into real estate, insurance and law. Louisville was the headquarters for the Military Division of the South until the federal government withdrew the troops from the southern states during the 1870s. Ex-Confederate soldiers such as Bennett Young, J.J.B. Hilliard, Basil Duke and John B. Castleman stayed in Louisville and became notable figures in the city's Gilded Age.

Louisville had the advantage of the Ohio River, with its connection to many other navigable waterways. On February 18, 1870, the first bridge across the Ohio River at Fourteenth Street was completed, and on March 1,

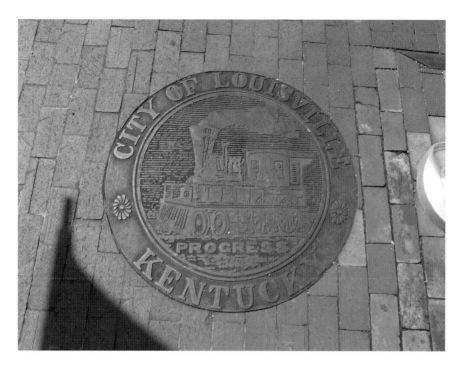

City of Progress plaque that was originally placed at the Louisville City Hall. It now resides in front of the Frazier History Museum. *Courtesy of the author.*

the first train crossed the bridge. In 1886, the Kentucky and Indiana Bridge was the first multimodal bridge to cross the Ohio River and allowed both a railway and two wagon ways, which allowed wagons, streetcars, pedestrians on foot and other animal-powered vehicles to cross into New Albany, Indiana, from Louisville. In 1895, the Big Four Bridge was completed. The bridge was a six-span railroad truss bridge that crossed the Ohio River, connecting Louisville with Jeffersonville, Indiana. The name came from the Cleveland, Cincinnati, Chicago and St. Louis railways.

With the advent of railroads, Louisville had a cheap and easy method of communication with all the important points on the continent. Louisville had connections with the North, South, West and seaboard cities. The Louisville & Nashville Railroad was chartered on March 2, 1850, and the first train ran to Nashville for 185.23 miles in November 1859. In 1870, the Knoxville branch was opened to Lexington. On February 24, 1860, the Bardstown branch of the Louisville & Nashville Railroad was completed and purchased by the L&N in June 1865. In November 1868, the Richmond

line was completed. On January 19, 1877, the Cecilian branch was completed; in 1868, the Glasgow branch was completed under the control of the Barren County Railroad; and in September 1860, the Memphis branch was completed and was operated in connection with the Memphis, Clarksville & Louisville and the Memphis & Ohio Railroads. On May 4, 1871, the Nashville and Decatur railroads were leased to the L&N, and on October 1, 1872, the South & North Alabama Railroad was completed. The L&N purchased the Cumberland & Ohio Railroad from Lebanon to Greensburg, which was completed in 1879. In 1879, the company also bought the Tennessee division of the St. Louis & Southwestern Railroad and the Kentucky division of the same railroad.

The L&N purchased the majority of stocks in other railroads, such as the Nashville, Chattanooga & St. Louis railway system, the Owensboro & Nashville Railroad and the Mobile & Montgomery Railroad. It leased the New Orleans & Mobile Railroad and the Pontchartrain Railroad. It leased the Southern division of the Cumberland & Ohio Railroad, the Indiana and Illinois division of the St. Louis & Southeastern Railroad and the Selma division of the Western Railroad of Alabama. It also purchased the Pensacola Railroad and the Pensacola & Selma Railroad. In 1885, the L&N had control of 2,027 miles of track and transported 569,149 people.[6] The man most responsible for the expansion of the L&N Railroad was Victor Newcomb.

The first president of the Louisville & Nashville Railroad was L.L. Shreve, who was appointed by the board of directors on September 27, 1851, and resigned in 1854. In 1884, the president of the railroad was Milton H. Smith. More than twelve thousand men were employed by the company, and the capital stock in 1885 was $30 million.

The Louisville, New Albany & Chicago Railroad main line ran from New Albany to Michigan City for 228 miles, and its branch, Chicago & Indianapolis Airline, which ran from Indianapolis to Chicago for 176 miles, connected the two cities by the short line and also connected with the Monon, Indiana line. The railroad was founded on January 25, 1847, and opened in 1852.

The Jeffersonville, Madison & Indianapolis Railroad ran from north of the city; crossed the Ohio & Mississippi railway at Seymour, Indiana; formed a junction with the Madison branch at Columbus; and connected with Indianapolis with 110 miles. The Pennsylvania Company also operated the Shelby & Rush Railroad and the Cambridge Extension for a total of 225 miles.

The Ohio & Mississippi Railroad connected with Louisville with a branch in North Vernon, Indiana. The Louisville branch ran from North Vernon to Jeffersonville with 52 miles. The Ohio & Mississippi ran from Cincinnati to St. Louis, and its Springfield division ran from Shawneetown to Bardstown, Illinois, for a total of 615,000 miles. The railroad was completed in 1867 and built by two corporations.

The Chesapeake, Ohio & Southwestern ran from Richmond, Virginia, to Huntington, West Virginia. From Huntington, the railroad was constructed to Mount Sterling, Kentucky, where the line connected with the Louisville, Cincinnati & Lexington Railroad. The Chesapeake, Ohio & Southwestern Railroad was completed in 1881 and formed the most direct route between the eastern seaboard and the West. The railroad supplied coal, iron and timber. The railroad company also bought the Elizabethtown & Paducah Railroad, which established a connection with the Iron Mountain Railroad at Cairo, Illinois. With this connection, Louisville was open to trade with the entire Southwest and to the sea. The owners of the Chesapeake, Ohio & Southwestern Railroad were also owners of the Western division of the Southern Pacific Railroad and made their railroad the Eastern or Atlantic division of the inter-oceanic system of the South. The arrangement added to Louisville's importance as a railroad center.[7]

The Louisville, New Albany & St. Louis railway gave Louisville the most direct line from the West and formed the shortest line between the oceans in connection with the Missouri Pacific, Union & Central Pacific, together with the Chesapeake, Ohio & Southwestern.

The Louisville Southern Railroad gave Louisville a direct southern route with the Danville and the Cincinnati Southern to Chattanooga, placing Louisville in immediate connection with the southern Atlantic seacoast through a railroad system centering at and extending east and south through Virginia, Georgia and Alabama. Former Confederate colonel Bennett Young was the founder of the Indiana and Kentucky Bridge and the Louisville Southern Railroad.[8]

Streetcar railways were intricately tied to the rise of manufacturing. They provided the necessary transportation for workers who had to live on the outskirts of the city, where new housing could be built inexpensively. General Jeremiah Boyle, who was a Union general during the Civil War, founded and was president of the Louisville City Railway; he also ran a franchise to operate streetcar lines on Main and other streets. At Twelfth Street, the City Railway connected with the old Louisville & Portland. Boyle secured a parallel route on Portland Avenue. He eventually extended his lines on Preston to Lion

Garden at St. Catherine on Second Street to Breckinridge and on Broadway to Cave Hill Cemetery. The Central Passenger Railway built lines on Fourth Street to Oak Street and onto Walnut between Eighteenth and Baxter. The Citizen's Passenger Railway ran lines on Market between Twentieth and Woodlawn Garden at the east end of Market Street. The Beargrass line had lines from Bardstown Turnpike to Doup's Point and then along the Taylorsville Turnpike to the area of Bowman field. By the 1870s, there were fifty miles of streetcar lines, carrying 8 million passengers per year.[9]

Louisville had a great supply of real estate. The city was built at the northern edge of a plain covering 70 or 80 square miles. The corporate limits of the city included about 12.5 square miles with 144 miles of paved streets. There were 124 miles of horse and steam and suburban railways. The street railway lines had a fixed fare of five cents and a system of transfers that helped build up the suburbs and relieved the pressure on the city. The streetcar system resulted in making desirable property cheaper for manufactories, residences and businesses. By 1889, the electric trolley car had replaced the older mule-drawn cars, and by 1890, all the local lines had merged into the Louisville Railway Company. The new company set about to convert the major routes to electric operation.

In 1880, the value of land was assessed at $27,149,665; by 1887, the value had increased to $31,550,000. The homes in Louisville were cheap, and workshops and business were taxed lightly or had fair rentals. The cheapness of real estate, the proximity of raw materials and fuel and the increase of railroad lines were the main factors that contributed to Louisville becoming a major industrial city. "Shotgun" cottages, which were borrowed from New Orleans, were built for the working class on the outskirts of the city. Each cottage had a narrow lot of land.[10] While the population increased 25 percent, from 1870 to 1886 the manufacturers increased 100 percent; while the population from 1880 to 1886 increased about 40 percent, manufacturers increased almost 90 percent. The resident population was being used in manufacturing companies, which led to skilled and educated mechanics.[11]

With the newfound money in Louisville, industrialists and financiers gave a substantial amount of their wealth to improving the city. For example, in 1887, tan leather business owner Colonel Andrew Cowan sent a proposal to the Salmagundi Club to fund a system of parks and wanted the business community to support the effort. In 1890, the Board of Park Commissioners was empowered to select land to build the new park system. Iroquois Park was the first park to be planned, with a Grand Boulevard that connected a

road from downtown to the southwest. Eventually, Southern, Eastern and Western Parkways connected all the parks. Cherokee Park in the East End was purchased in 1891, with Shawnee Park in the West End a year later. Frederick Law Olmsted designed the new park system with landscapes, road systems and planting patterns. The arrival of the electric trolley car and the parks created a boom in real estate.

During the Gilded Age in Louisville, since there was an abundance of wealth, Louisville residents could indulge in the new outlets for entertainment. There was the Masonic Temple on Fourth Avenue and Jefferson Street that hosted Oscar Wilde and Mark Twain. There was Macauley's Theater on Walnut Street, near Fourth Avenue, where Mary Anderson gave her infrequent Louisville appearances. Macauley's Theater also offered Louisville residents performances of Shakespeare and by Buffalo Bill. In 1883, Macauley hosted the American premiere of Henrik Ibsen's masterpiece *A Doll's House*, with Helen Modjeska in the title role. The Liederkranz Hall, built by the Liederkranz Society, was used by touring opera companies and by German-language theatrical troupes. The Buckingham, owned by brothers John and James Whallen, opened in Louisville. They presented vaudeville and burlesque shows. The Whallens also opened the Grand Opera House on the north side of Jefferson Street, between Second and Third Streets, only a block away from the Buckingham. In 1898, the location of the Buckingham was moved to the Grand Opera House. There was also the Harris Museum on Fourth Avenue.

In 1874, Churchill Downs was organized as the Louisville Jockey Club. The Kentucky Derby was the showpiece of the new approach to horse racing. A $1,000 purse was given to the winner of the three-year-olds. On opening day on May 17, 1875, more than ten thousand people attended, which was the largest for any opening of a new track or the first running of a new stakes race. In 1889, William F. Norton Jr. built the Auditorium at Fourth and Hill that could seat three thousand people. The back of the Auditorium also had an outdoor amphitheater. He held firework displays with themes like "Burning of Moscow" and "The Last Days of Pompeii." He also held bicycle races and other outdoor events. He brought musicians and singers to Louisville from New York and Boston symphonies, the Metropolitan Opera, Edward Strauss's orchestra from Vienna and regular seasons of opera, including Gilbert and Sullivan. The Auditorium also was the home of drama, and the great names of the nineteenth-century stage appeared there, including Ellen Terry, Sarah Bernhardt, Lillian Russell, Nat Goodwin, Edwin Booth and Lawrence Barrett.

With the influx of new wealth, Louisville residents could support the arts community. Carl Brenner was known for his landscapes, and Nicola Marschall, who designed the Confederate uniform and Confederate flag during the Civil War, was a portrait artist who moved to Louisville after the war. Aurelius O. Revenaugh was also a portrait artist in Louisville. Patty Thum was a female artist whose work was showcased at the Southern Exposition. Native Louisville resident Enid Yandell, who studied art under Auguste Rodin, did work on the exterior decoration of the Women's Building at Chicago's Columbian Exposition. She later executed the statue of Daniel Boone and Hogan's Fountain at Cherokee Park and the figures for Louisville's Confederate monument, which is now located in Brandenburg, Kentucky.

During the Gilded Age in Louisville, there was an explosion in banks, stores, drugstores, hotels, merchant shops and factories. Banks increased from three in 1819 to twenty-nine in 1883, and by the turn of the century, Louisville had become the largest banking capital in the South. Wholesale and retail stores increased from 36 in 1819 to 1,555 in 1883; commission stores increased from 14 in 1819 to 60 in 1883; bookstores increased from 3 to 29 in 1883; printing offices increased from 3 to 39; drugstores increased from 3 to 93; hotels and taverns increased from 6 to 32; groceries increased from 28 to 786; merchant shops of all kinds increased from 64 to 1,109; steam factories and mills increased from 3 to 487; and other types of factories increased from 11 to 515.[12]

To showcase the rising importance of manufacturing, on September 3, 1872, the city opened a Louisville Industrial Exposition. A building was constructed on the northeast corner of Fourth and Chestnut. The Industrial Exposition showcased the city's manufacturers, who displayed their products for sale to potential buyers. The directors of the exposition were the city's top industrialists, including J.H. Wramplemeier, Charles Snead and George Ainsle, who were foundry men; papermaker and railroad promoter Biderman Dupont; and railroad financier H. Victor Newcomb. John T. Moore, a paper manufacturer and wholesale grocer, was the president of the exposition. In 1877, the telephone, invented by Alexander Graham Bell, was featured at the Louisville Industrial Exposition. In 1879, the American District Telegraph Company brought the telephone into Louisville homes and businesses. James Breckinridge Speed was president of that company. Speed was already president of another one of Louisville's industrial markets, the Louisville Cement Company.

Another one of the highlights of the Industrial Exposition was the electric lightbulb. In 1878, arc lights were installed in William Kelly's axe factory on Portland Avenue and in James Lithgow's Eagle Foundry at Main and Clay. Five years later, at the Southern Exposition, which opened its doors in 1883 and ran until 1887, the electric incandescent lightbulb, invented by Thomas Edison, was showcased. The Southern Exposition also featured agricultural machinery and technical innovations. With more than 1,500 commercial and mercantile attractions, the Southern Exposition exhibited its wares hoping for buyers. More than 4,600 incandescent lightbulbs were installed at the Southern Exposition building. The Southern Exposition was Louisville's single most ambitious promotional effort. The exposition was also financed completely with local private capital.

Fueling the massive foundries and mills in Louisville required coal and coke. Louisville became a distributing point for southbound coal, both by river and railways. In 1887, about $3 million of Pittsburg coal was handled in the Louisville Harbor annually, with about two-thirds going downstream. The coal was distributed all along the Ohio River and the upper and lower Mississippi, with more than ten million tons annually reaching New Orleans and the lower coast. The L&N Railroad also brought in coal to Louisville from the Jellico and Laurel Mines.[13]

Banks were needed to fund the immense commerce and trade in Louisville. There were twenty-one banks in Louisville in 1883, including the Bank of Kentucky, Bank of Louisville, Bank of Commerce, Falls City Bank, Farmers and Drovers Banks, German Bank, German Insurance Bank, German Security Bank, Louisville Banking Company, Masonic Bank, People's Bank, Western Bank, First National Bank, Second National Bank, Third National Bank, Fourth National Bank, Citizen's National Bank, German National Bank, Kentucky National Bank, Louisville City National Bank and Merchants National Bank. The banks had a combined capital of $9,201,800, with a surplus of $2,565,279.

During eight months in 1887, there were 1,400 new buildings erected at a total cost of $4 million.[14] For example, in 1872, the Louisville Public Library opened, and the following year, the new Louisville City Hall was completed. In 1874, the Alms House was completed, with the Louisville Clearing House following the next year. On October 8, 1878, the Louisville College of Pharmacy and the American Printing House of the Blind opened, and on October 24, the Masonic Widows and Orphans Home was established. On October 25, the Masonic Grand Lodge opened. In 1880, Durkee Famous Foods, the Theodore Tafel Surgical Instrument Company and Ballard and

Ballard Flour Mill opened. In 1881, the Kentucky Elevator Company was founded. The Louisville Electric Light Company opened in 1882. The next year, the Ohio Valley Telephone company got its start. In 1887, the Astoria Veneer Mills and Lumber Company, the J.F. Kurfees Paint Company, the Seelbach "European Style" Hotel and the Frey Planning Mill Company were founded. In 1889, Gould-Levy Broom works opened. In 1891, the J.C. Heitzman Bakery, Ohio River Stone Company and J.J. Mueller Tailoring Company got their start. In 1893, R.C. Schlich & William Mayer established the first commercial photo engraving business in the city. These businesses were just a small fraction of the construction that arose across the city during the Gilded Age.

Two of the leading industries in Louisville during the Gilded Age were whiskey and tobacco. The American Industrial Revolution changed the bourbon industry and transformed the spirit from small-batch production to the bourbon that Americans know today. Whiskey bourbon became a leading industrial product in the state. There are several areas in Kentucky that claim the first manufacture of whiskey. Mason County claimed that the first Kentucky distillery was located a few miles from the present town of Maysville. Nelson County also claimed to be the first location of a distillery. Mercer County claimed that the first distillery was built in Harrodsburg, which was the earliest permanent settlement in Kentucky. General James Wilkinson was the owner and operator of the distillery, but he did not arrive in Kentucky until 1784.

In 1783, Evan Williams built and operated a still at the corner of Fifth and Water Streets in the settlement of Louisville, at the Falls of the Ohio. He used the abundant supply of corn to make his whiskey. Williams was Kentucky's first commercial distiller. He was also a member of the Board of Trustees of Louisville. Before he became a member of the board, a rule had been adopted forbidding liquor during the meetings, under penalty of censure, as well as a fine of six shillings if the law were broken a second time (in addition to the seizure of the liquor). Williams did not know about the rule and brought a bottle of his own whiskey to the meeting for the refreshment of his fellow members. The members seized his liquor but without censure. At the end of the meeting, Williams left with an empty bottle. At the next meeting, Williams brought another bottle, but Will Johnson, the county clerk, declared that Williams ought to be expelled for making and offering to the board his whiskey. The clerk was also surveyor of the port and was accustomed to the use of imported wines and liquors. In his defense, Williams insisted that the clerk had the taste of an aristocrat,

and the board agreed with him—again Williams left with an empty bottle without censure. Williams continued to make his whiskey without license until 1788, when he was forced to pay his license and continued to run his distillery.[15] In the 1780s, James Spears, a distiller from Paris, Kentucky, first used the term *bourbon*.

In 1787, a great boost in the manufacture of whiskey in Kentucky came in the form of a colony of immigrants from Maryland that arrived in the state. They were known as the "Catholic League." Sixty families came down the Ohio River in flatboats and settled in Nelson, Washington and Marion Counties. They brought with them the knowledge of distilling and established early distilleries along the Salt River, down which they sent their product to the settlements and the cities of the Ohio and Mississippi Rivers. Nelson County possessed an abundant supply of limestone water. Nelson County was and remains the principal center for distilleries in Kentucky and made the finest whiskies in the state.[16]

Elijah Craig was credited with being the first distiller to age his whiskey in charred oak barrels. No one knows how he began charring his barrels. Once he began using this process, though, the whiskey adopted an amber color and a distinctive flavor that makes what we know today as bourbon. Many consider Craig the father of bourbon.

In 1791, an excise law was passed by Congress for the purpose of raising federal revenue. The distillers in Pennsylvania generally opposed the tax, and in 1794, they publicly opposed it. President George Washington told the insurgents to disperse and warned the people not to resist the federal government. The militia was called out and directed to quell the rebellion. The insurgents backed down, and General Harry Lee issued a proclamation granting amnesty to all who had submitted to the laws; the insurgents also had to take an oath of allegiance. The insurgence was known as the Whiskey Rebellion of Pennsylvania. With the law passed, many of the distillers in Pennsylvania moved to Kentucky, settling in Mason County. The government of Kentucky did not interfere with the distillers, and they were able to convert their corn into whiskey without a tax. Whiskey became a form of exchange and a standard of value. The product was in universal demand and did not deteriorate; in fact, it improved with age. The product could be easily transported and could be disposed of in any town or city along the Ohio or Mississippi Rivers. Settlements of accounts were made in whiskey, and many professional men received their wages in whiskey.[17]

In 1794, Alexander Anderson of Philadelphia introduced the perpetual steam still. By 1801, whiskey and tobacco had replaced flour as the principal

export crops from Kentucky's interior, with 56,000 gallons traveling down the Ohio River and passing through the Louisville Customs House. About 250,000 gallons of whiskey by 1810 and 2,250,000 gallons by 1822 were being transported down the Ohio River.[18] By 1815, the steam-powered perpetual still was being used as far west as Kentucky, and by 1818, the perpetual still had replaced the copper still that George Washington and Evan Williams would have used in their whiskey production. By 1830, Aeneas Coffey had invented the column still, an advanced variant of Anderson's perpetual still. Coffey's still could produce 3,000 gallons of raw whiskey in an hour.[19]

Scotch native James Crow studied medicine and chemistry at Edinburg University. In 1823, he immigrated to Kentucky and opened his own distilleries. He owned Glenn's Creek Distillery and later Old Oscar Pepper Distillery. He applied the scientific method to distilling. He used saccharimeters to gauge the sugar content of the mash and thermometers to regulate the mash's temperature and took careful measurements of acidity levels throughout the process. His contribution to the history of the sour mash process for regulatory batch consistency was when he added a small quantity of leftover mash (the mixture of grain, malt, water and yeast) from the previous batch. By doing so, he was able to regulate the pH levels in each run of the still, enabling consistency on a large scale.[20]

The invention of bigger and more efficient stills and James Crow's palatable bourbon helped to produce a quality product on a large scale, but whiskey bourbon went into decline. By 1846, there were no distilleries in Louisville. In 1821, the Hope Distillery turned out one thousand gallons of whiskey, but the company was a failure because it ran out of people to drink the product. Steam power, modern buildings, advanced machinery and high volume stills helped with production, but once made, the whiskey bourbon could only be delivered by either wagon or steam-powered boats, which could take months to deliver the product to the East Coast or New Orleans.[21]

After the Civil War, the production of whiskey made a comeback. Railroads changed how bourbon was delivered. By 1865, there were 35,000 miles of track, 53,000 miles by 1870, 93,000 miles by 1880 and 164,000 miles by 1890. When the Louisville & Nashville Railroad connected with other railroads, the trains could now reach the East, West, South and North delivering bourbon over the entire county and even overseas with steam-powered ocean liners. The American Industrial Revolution changed the farm with the introduction modern equipment, such as Avery's plows, and artificial fertilizers. Corn production in 1860 was 838.8 million bushels per

year, but by 1900, corn production had risen to 2.7 billion bushels per year. More corn meant more whiskey and bourbon.[22]

But with the gilded lining, the major corporations took over the small stills and turned the business of bourbon into a multimillion-dollar industry. The building of bonded warehouses, the knowledge of intricate laws and rulings required and the great expense essential to achieve compliance with all the demands of the government, together with the capital required to meet the taxes as they matured, had the effect of gradually squeezing out the farmer who made whiskey on a small scale and put the manufacturing of the product into the hands of corporations and individuals with strong financial resources. The bourbon industry was almost ruined by deceptive practices such as adding flavoring or colors to bourbon to mask inferior quality. The master distillers in Kentucky took back their product and demanded regulations. Batches were tested, and bourbon was bottled with bonded labels to make sure that the product was not tampered with; other government regulations made sure that what was in the bottle actually was bourbon.

In 1880, Kentucky saw 15,011,279 gallons of whiskey made in the state, but by 1895, that had increased to 22,814.950. Kentucky distillers spent millions of dollars per year in the purchase of grain, fuel, barrels and machinery, as well as for labor, insurance and transportation. In 1895, there were nineteen distillers in Louisville, handling the outputs of Nelson, Davies, Anderson and other counties. Several of the distilleries had the warehouse capacity for more than 100,000 barrels of whiskey. The production of and trade in fine bourbons was one of the greatest industries in Kentucky and took up a large amount of capital in Louisville. The city was the collection center and contained one hundred registered grain distilleries. The producing capacity was 82,000 gallons per day. The gross product during the five years ending in June 1887 was 35,000 gallons, with internal revenue taxes amounting to $29,154,319.[23] By 1904, 436,013 barrels were being shipped from Louisville, which converts to 21 million gallons of whiskey bourbon. Louisville handled one-sixth of the total consumption of the United States and was the largest market for fine whiskey in the country. The value of the shipments was $36,991,040. The total production of whiskey bourbon in the state of Kentucky for 1904 was 23,070,162 gallons, of which 11,398,394 gallons were produced in Louisville. By the turn of the century, Louisville led the world in whiskey bourbon.[24]

Some of the distillers in Louisville included J.M. Mattingly & Sons, located on High Avenue in Portland with its office on 205 West Main

Street; Block, Franck & Company, located on 205 West Main; J.B. Wathen & Brothers Company, located on 141 West Main Street; the Anderson & Nelson Distilleries Company, located on 116 East Main Street; Applegate & Sons, located on 122 East Main Street; the Parkland Distillery Company, located on 126 East Main Street; Hollenback & Vetter, owner of the Glencoe Distillery, located on 234 Second Street; the Ashton Distillery Company, located on 120 East Main; John Roach, maker of "Old Times," located on 104 East Main Street; J.H. Cutter, maker of Old Bourbon; C.P. Moorman & Company, located at 104 East Main Street; the Marion County Distillery, located on Thirty-First Street and Rudd Avenue; and J.M. Atherton Company, located on 125 West Main Street.

During the Gilded Age, Louisville was home to the largest tobacco market in the world, the largest tobacco re-handlers in the world and the largest tobacco manufacturers in the world. The state of Kentucky produced almost 50 percent of the total American crop. Louisville was the chief dealer in tobacco. One-third of all tobacco raised in North America was handled in the warehouses of Louisville in 1885 and 1886. Louisville's great importance as a tobacco market was due to the city being the only one in the United States where all grades could be obtained. Tobacco became an early feature in Kentucky's culture. The settlers from Virginia were tobacco planters, and tobacco was one of the first crops grown in Kentucky. The

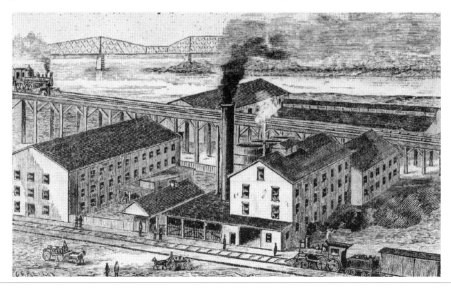

Marion County Distillery, located at Thirty-First Street and Maple Street. *From Elstner's* The Industries of Louisville, Kentucky and of New Albany, Indiana *(1887)*.

J.M. Mattingly Distillery. *From Elstner's* The Industries of Louisville, Kentucky and of New Albany, Indiana *(1887).*

settlers who moved to Kentucky arrived in 1775, and eight years later, the crop had become an important staple. The state built warehouses for storing and inspecting tobacco. One of the warehouses was located on the land of Colonel John Campbell in Louisville; another was located at the mouth of Hickman's Creek, on the Kentucky River; and a third was located at Leestown, just below Frankfort. Campbell erected another warehouse in Shippingport and another on the Beargrass Creek.[25]

Tobacco could be easily transported by flatboat and demanded a cash sale. It was a legal tender of the payment of debts under the laws of Virginia. On June 28, 1794, the Virginia Laws were repealed when it came to payment of tobacco for court fees. In 1810, cultivation of the crop began in Logan County. By 1820, a number of planters had begun to grow crops in that area. In Green, Barren, Hardin and Warren Counties, the cultivation of the crop began at about the same time as in Logan.

The foreign trade of tobacco became important as well, and companies arose to strip the tobacco and make cigars, snuff and chewing tobacco. Elisha Applegate was the first tobacco dealer in Louisville. He was born on March 25, 1782. He handled and sold tobacco for forty years. In 1835, there was only one warehouse, on Seventh and Main Streets. In 1844, a second warehouse was built by Joshua Haynes and John Rowzee on Floyd and Preston Streets. In 1851, George Green and Thomas Rowland built the Farmer's Warehouse on Second, between Main and the River. Another warehouse was built by Page & Ronald on Main Street. In 1851,

the Pickett Warehouse was built. The proprietors were Joshua Haynes and Andrew Graham. Graham became one of the most noted and daring speculators in tobacco. The warehouse was named after James Pickett, a pioneer warehouseman.

Trade amounted to ten thousand to twelve thousand hogsheads of tobacco per year. In 1855, a commission house was built on Ninth Street. John Brent and Frank Ronald were the owners. In 1861, the Boone Warehouse was built, owned by Captain William Glover. In 1863, the reopening of the Louisville House took place. The owner was James Phelps, and his sons operated the Planters Warehouse.

In 1870, Page and Ronald Company built the Farmers Warehouse. The original Farmers Warehouse was unsuccessful, but Page and Ronald opened a new warehouse and gave the building the same name. In 1895, there were twenty warehouses, including Pickett; Boone; Growers; New Enterprise; Farmers; Grinter & Company; Kentucky; Brown, Tate & Company; Rice & Givens; Central; Golden Rule; Eagle; Major & Owen; Planters; Falls City; Louisville; Green River; Ninth Street; Gilbert and Sawyer; and Wallace & Company.

Besides the Civil War, the factor that had the greatest influence on the tobacco market was the revitalization of burley tobacco. Burley was one of the most profitable crops that could be grown and was raised in the Bluegrass region of Kentucky. Pastures that were once used for the raising of Thoroughbreds were plowed up to raise burley tobacco. The tobacco

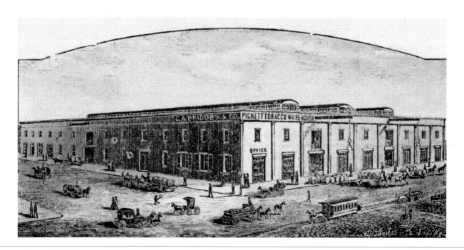

Pickett Tobacco Warehouse, located at the corner of Eighth and Main Streets. *From Elstner's* The Industries of Louisville, Kentucky and of New Albany, Indiana *(1887)*.

merchants in Louisville met with Milton Smith, the president of the Louisville & Nashville Railroad, to state their case. Smith readjusted the tariff on tobacco, and the railroad cooperated with the river transportation companies on the Kentucky rivers in bringing Louisville the burley tobacco from the fields.

In 1850, Louisville sold 7,500 hogsheads of tobacco, and by 1895, the city was selling 174,885 hogsheads. In 1889, there were 61,641 planters of tobacco, there were 274,587 acres devoted to the crop and the total value on the farms was $13,155,297. In 1895, Kentucky ranked third in the number of establishments devoted to the making of chewing and smoking tobacco and snuff, fifth in the amount of capital invested, third in the value of wages paid, fourth in the number of employees, fourth in the value of raw material used and third in value of the finished product.

The state had a growing industry in making cigars. In 1879, there were 144 businesses engaged in the industry, with a capital of $528,297, annual wages of $375,259 and a total value of $1,058,039. In 1894, the number of cigars made in the state was 42,026,065, and there were 295 factories. Of these cigars, 14,364,040 were made in Louisville. Chewing tobacco, plug and fine cut, amounted to 18,074,640 pounds for Louisville alone.[26]

R.N. Edwell & Company, located on 129 Third Street, owned the Louisville cigar factory. R.P. Gregory manufactured cigars. The Franklin Tobacco Company, located on 633 and 635 East Main Street, manufactured half dime, gingerbread nip and chewing tobacco. Jacob Dautrich, located on 1405 Shelby Street, made cigar boxes.

On January 7, 1889, Nick Finzer was president of the Leaf Tobacco Exchange, which was made up of both buyers and warehousemen. The exchange replaced the Tobacco Board of Trade and the Louisville Leaf Tobacco Buyer's Association. In 1885, the buyer's association was dissolved. On February 12, 1876, the Board of Trade was organized by the buyers and warehousemen. By 1895, each had become its own separate organization, but the exchange was the principal body, with J.S. Bockee as president.

Louisville had the reputation of being one of the leading tobacco plug centers in the world. The Finzers, the Doerhoefers, the Weissingers and the Matthewses built immense factories that employed thousands of workers. The American Tobacco Company was important in the manufacture of chewing tobacco. John Doerhoefer was made director of the company, and Louisville became the base from which most of the tobacco supplies were drawn and the center of plug tobacco.

The buyers formed another important element of the tobacco trade. Many were agents of foreign government monopolies. Others bought and sold on their own, and still others acted as brokers for manufacturers or exporters. James Clark, Daniel Spalding, W.G. Meier, Anderson Burge and many others were connected as buyers. Historic firms of Liverpool, London, Bremen and Antwerp had resident agents, and resident agents for the government monopolies of France, Spain and Italy were in the city.

Tobacco was sold in hogsheads, or wooden casks. The staves of the cask are lifted off, and the mass is broken into three points, from which samples are drawn. The samples are taken from any point in the hogshead and are meant to represent the quality of the entire cask. When the sample "hands" are drawn, an inspector stamps them with an official seal as a guarantee that the whole will come up to these specimens. The buyer examines the samples and bids. The breaking of the hogsheads to draw samples is known as "the breaks."[27]

During the Gilded Age, Louisville was the largest market in the United States and the largest market in the world for jeans and jeans clothing. In 1880, there were four large mills engaged, employing about $1,120,000 worth of capital and 1,250 employees and producing annually nearly 7.5 million yards of cloth, valued at $2,250,000. In 1887, the capacity of the industry increased 20 percent. In just ten years, the industry increased eightfold.[28]

Louisville was also the largest manufacturer of cast-iron gas and water pipe in the United States, under the firm of Dennis Long & Company, of the Union Pipe Works, which in 1887 enlarged its capacity by 50 percent. The Union Pipe Company employed four hundred people and had a capacity of 250 tons of iron daily.

There were twenty-nine foundries in the city of Louisville making stoves and architectural and other commercial iron products, employing about four thousand men and consumed about 150,000 tons of coal annually. Louisville ranked fifth among the cities of the United States as an iron consumer. The city also became a great storage market, with immense supplies stored in warehouses that supplied the demands of the country.[29]

The rolling mill industry made boiler iron, plate and bar. It made steamboat and general steam boilers, railroad car wheels, railroad car and wagon axles, wrought forgings and miscellaneous iron workings. Ainslie, Cochran & Company, which was located on Main and Tenth Street, owned the Louisville Foundry and Machine Shop. A.B. Burnham & Company was a wholesale tinner that made stoves, tin ware and plates. It was located

on 122–26 Eighth Street. Henry Disston & Sons, located on 250 and 852 West Main Street, made steel tools, saws and files. George Meade, located on the corner of Third and Jefferson, made pig iron. Thomas Mitchell manufactured tanks and boilers.

Louisville had a thriving brewing and malting industry employing about five hundred workers with an annual product worth $2.5 million. There were six large breweries in Louisville. Louisville also made ladies' dresses, men's shirts and fine suits, employing about one thousand tailors and seamstresses. Wanamaker & Brown, located on the northwest corner of Fourth Street and Jefferson Street, made clothing. R. Knott & Sons, located at 557 Fourth Avenue, made dresses and carried fashionable dry goods.

Louisville led the world in farm wagons. The city also had a large flour mill that made 1,600 barrels of flour per day. W.H. Edinger & Brothers, located at 133 and 137 East Main Street, was a wholesale flour dealer. A line of manufactured steam bakery goods—including bread, crackers and cakes—was made in the city. The manufacture of confectioneries also took hold in the city, including Frank Meene, who made the Eagle Brand of chocolates and produced seventy-five thousand pounds of candy in 1898, and Bradas and Gheens, which made Nightingale and Anchor Brand of chocolates and was the oldest continuously operated candy factory in the United States and the largest chocolate factory in Kentucky.

Louisville was also a leader in making trunks and valises. P.J. Botto & Company, located at 335 Market Street, made trunks and travel bags. Chilton, Guthrie & Company, located at Twenty-Fourth and Main, manufactured trunks, valises and bags. Shoe manufacturing also became one of the most prominent and prosperous trades in the city and reached its peak in 1886. Theodore Cimiotti & Company, located on 303, 312 and 314 Seventh Street, made men's shoes and boots.

Louisville once held the world's attention as a center of winter pork packing, but when the railroads extended to the West, the industry began to fade. Still, companies like McFerran, Shallcross and Company were known for their famous "Magnolia Hams." Refrigeration permitted Louisville packinghouses to work in the summer as well as winter, and Louisville increased its production to meet the demand of home and regional markets. H.F. Vissman & Company, located at Story Avenue and Buchanan Street, was a pork and beef packer.

In 1887, C.C. Mengel Jr. & Brothers shipped lumber abroad and eventually owned its own fleet of ocean vessels to transport its lumber overseas.[30] Charles Dearing was a bookseller, and his shop was located on

the northwest corner of Third and Jefferson Streets. Dupont & Company, located on 226 Sixth Street, made paper, and John Morton Company was a publisher, with his company located at 440–46 West Main Street.

One of the industries in Louisville that was unsurpassed in any other part of the world was the manufacture of plows. There were four companies that made a product valued at $2,275,000 and employed 1,925 workers. B.F. Avery, Thomas Meikle, McCormick Harvest Machine Company and Brinly-Hardy Company all made plows in Louisville. B.F. Avery was the largest in the world and sent its plows to every country in the world where modern agricultural methods were used. The number of plows made in Louisville in 1880 reached 80,000. In 1886, the production increased to 190,000, and the industry was enlarged again in 1887. In 1880, the value of all agricultural implements manufactured in Louisville in 1880 was $1,220,000; today, that value is $27,735,729. By 1887, the value of plows had nearly doubled.

Louisville led the world in hydraulic cement, and most of the cement was made largely from the mills operating on the cement stone in the bed of the Ohio River. The cement factories produced 1 million barrels annually. In 1887, the sales for cement reached 850,000 barrels. By the end of the century, Clark County, Indiana's thirty cement mills made the area one of the nation's leading cement producers in the country. One of the giants in the industry was the Western Cement Company, which was located on Third and Main Streets in Louisville. The firm's president was R.A. Robinson, and James Breckinridge Speed was vice-president. In 1887, the Western Cement Company was the selling agent for all the celebrated brands of Louisville hydraulic cement. In 1829, John Hulme & Company began the manufacture of Louisville cement at Shippingport, which was once located near the foot of the Louisville & Portland canal. Louisville cement was recognized as the best natural article manufactured in the United States. The Louisville brands comprised Star, Diamond, Anchor, Acorn and Fern Leaf cements, with two of the mills in Kentucky and six in Indiana. The Louisville brands were praised by engineers and architects around the country. In almost every state or territory west of the Allegheny Mountains where large public works had been constructed, Louisville cement was used either largely or exclusively—for bridges, waterworks, railroad buildings, government improvements on rivers and harbors, customs houses and large buildings of every size. Louisville cement was cheap to make with sand, and the cement set properly and hardened regularly and consistently. Louisville cement had the largest aggregate sale of all other cements west of the Allegheny Mountains. It was also used for street foundations and was preferred over other cements.[31]

Louisville led the world in tanned sole and harness leather. France took an interest in Louisville's kid leather. There were twenty-two tanneries in Louisville. The value of the annual product was $2.5 million annually, and nearly eight hundred workers were employed in the industry. Colonel Andrew Cowan made tan leather, as did D. Frantz & Sons, located on the corner of Franklin and Buchanan Street. George Cross, located at 413 Fourth Avenue, manufactured umbrellas and parasols as well as kid gloves.

Louisville was the largest market for the sale of mules. The city also manufactured wood and iron products. R.B. Cotter, located on 215 6th Street, was a dealer in pine and hardwoods. One of the largest veneering mills in the United States moved to Louisville from New York, constructed a large building, used forty acres of land and employed about 500 workers. Enrich & Andriot owned a wagon and buggy manufacturing company and was the largest company in the country at that time. The Bradley Carriage Company, located on 126–28 West Main, made carriages. The furniture manufactories employed 1,200 workers and made a product valued at $1,775,000 annually. The Kentucky Manufacturing company, owned by J.L. Eschman and located on Fifteenth Street, between Portland Avenue and Duncan Street, made furniture. The Louisville Manufacturing Company, located on 619–21 West Market, made furniture and bedroom suites.

Wholesale druggists also were a booming industry in Louisville. James Wilder and his brother, Edward Wilder, were some of the largest wholesale druggists in the country. Arthur Peter & Company, located on 716 and 718 West Main Street, was also a wholesale druggist. To meet the refrigeration needs of the meatpacking companies and local consumers, ice companies, such as the Talmage Ice Company, located on 505 Third Street, and the Pickett Artificial Ice Company, located on Floyd between Kentucky and Caldwell Street, supplied the city's growing need for ice. J.W. Reccius & Brother, located at 304 West Market, became the headquarters for baseball supplies, athletic and sporting goods. J.S. Clark & Company, located on Green Street, sold marble and granite. M. Muldoon & Company made monuments. J.M. Clark, located at 122 Second Street, made Hyman's sweet pickles and ketchup. The Louisville Tent and Awning Company, located at 172 Fourth Avenue, made tents and awnings. Sherman & Company, Samuel Chambers and Lewis & Hanford, located on 246 and 248 West Main Street, were wholesalers in seeds. Wholesale grocers were also profitable businesses, with J.W. Sawyer located on 354–56 East Market; Moore, Bremaker & Company located at 723 and 725 West Main Street; A. Engelhard located at 213 West Main; and Otter & Company located at 214, 216, 218 and 220

6th Street between Main and Market. Louisville had the largest soap factory in the South and the largest box factory in the world. Louisville also had the largest exclusive organ factory in the world.

By the end of nineteenth century, Louisville's population had increased to 204,000. The new transportation system was changing the form of the urban area. Annexed areas of the city became their own cities, such as Crescent Hill, Clifton, South Louisville and Parkland. Women began to make headways into the workforce. By the end of century, baseball had emerged as the national sport. Louisville had a ballpark at Twenty-Eighth and Broadway. The citizens of Louisville also discovered tennis and golf, organizing the Louisville Tennis Club in the 1880s and the Louisville Golf Club in 1893. In 1895, Churchill Downs built the familiar twin spires and a new grandstand. In 1899, the last gas streetlamp was replaced with a lightbulb. The foundation laid by the Gilded Age in Louisville would sustain the city into the early 1900s, and businesses continued to thrive. Automobiles, aero planes and motion pictures arrived in the city in the early 1900s. Manufacturing continued to spread beyond the Louisville city limits and entered into Highland Park and Oakdale. The success of the Gilded Age continued into the early twentieth century and could not have reached the heights it did without the foundation provided by the men who built the City of Progress in the 1870s, 1880s and 1890s.

JOHN G. BAXTER JR.

Mayor

John G. Baxter Jr. was born in Lexington, Kentucky, on December 12, 1826. He came to Louisville when he was a young man. His father, John Baxter Sr., was from Dundee, Scotland. His mother, Elizabeth, was a native of Pennsylvania. His father was a prominent manufacturer of linen and jute in his native country. When John Baxter Sr. and his family immigrated to America, he became involved in the hemp industry and established a hemp bagging factory in Lexington, Kentucky. He invented various mechanical appliances for the hemp-making process. His large factory in Lexington and his inventions would have made him very rich and wealthy, but he died at an early age. John Baxter Jr. was attending local schools, but when his father died, he had no choice but to make his way in life at the age of fourteen. He found a job as a clerk in a Lexington store and later found a job in the carriage manufacturing business. Although he completed his apprenticeship as a blacksmith, he decided to become a clerk and was interested in the sale of stoves and the manufacture of tinware. At the age of twenty-three, he managed to save $100, and at the end of his six years as a clerk, he went into a partnership in the stove and tinware business.[32]

In 1847, Baxter moved to Louisville and opened his first firm, A.A. Baxter and Brothers; he later changed the name to John Baxter, manufacture of tinware, and Baxter, Kyle & Company, which produced stoves. His business became intensely popular, with his trade in tinware and stoves extending into the western and southern states.

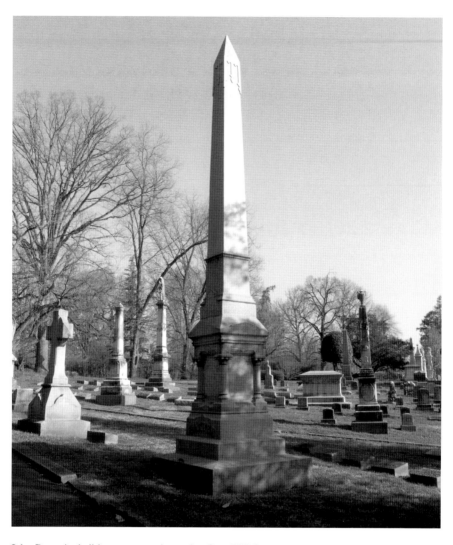

John Baxter's obelisk monument, located at Cave Hill Cemetery, Louisville. *Courtesy of the author.*

On November 7, 1852, he married Alicia Mary McCready. They had eight children: Mary, Elizabeth, Belle, John Jr., Annie, Emma, Carrie and Willie. From 1861 through 1863, he was elected to the lower board of the Louisville City Council and became president. In 1866, he was elected alderman and president of the board. He also served as school trustee and manager of the House of Refuge for six years. After the Civil War, he became president of the House of Refuge.

In March 1870, Baxter was elected mayor of Louisville for three years, and then he was reelected for three more terms. His administration marked an era of progress in the history of the city. He worked on a new city hall, at the corner of Sixth and Jefferson. He built a new Eruptive Hospital and started work on the Alms House. The most notable achievement of his administration was the improvement of the city's financial condition. The price of city bonds advanced from twenty to twenty-five cents and found ready buyers on the market.

As mayor, he bought nine steam fire engines, and the hook and ladder company was named after him, as was Baxter Avenue. The improvements to the cemetery on Jefferson Street, between Eleventh and Twelfth Streets, resulted in the place being named Baxter Square. In 1879, he was reelected mayor of Louisville. He was also connected with the Board of Education, and from 1868 to 1870, he was president of the Louisville & Nashville Railroad. In 1884, he was elected president of the Louisville Gas Company. He was also president of the board for the House of Refuge for six years.

On March 26, 1885, John sent Thomas Barrett, the president of Bank of Kentucky, a telegram stating that he had caught a cold while taking a bath in Hot Springs, Arkansas. He had been in ill health for some time. He had suffered from diabetes and rheumatism and hoped that the trip to Arkansas would improve his health. On March 30, he planned to return home. His wife had accompanied her husband on the trip. On March 30, 1885, Thomas Barrett received another telegram informing him that John Baxter had died in his hotel room in Hot Springs, Arkansas. As soon as information reached Louisville that John Baxter had died, a death notice and a piece of crepe paper were tacked on the door at the Louisville Gas Company and the business closed. Business was also suspended at his store and warehouse on 736 West Main Street. His body was shipped home to Louisville.[33]

Once his body arrived in Louisville by train, Mrs. Baxter, Miss Baxter, Captain W. Frank Harris, Dr. G.M. Keller, Dr. J.A. Brady, H.W. Davis and John Baxter were met at the depot by a large number of friends of John G. Baxter, including the Council Committee of Gilbert, Murrell, Hinkle, Stege and Bickel, two police lieutenants and a platoon of twelve officers. The entire party escorted his body to his home on 732 Third Street.[34]

A meeting was held at the office of George S. Moore & Company at 423 West Main Street to make funeral arrangements. The funeral took place at St. Paul's Church. The body was taken from his home by the pallbearers, honorary pallbearers and members of the council and other committees to the church. John McCoy, D.A. Fisher, John Leaf, J. Redman, David Rice,

George Vogt, Thomas Davie and John Allwine were selected from the employees at Baxter's foundry and store to be pallbearers. The honorary pallbearers were Booker Reed, George Morris, John G. Barret Jr., John T. Moore, William Ray, Thomas Barret, Dennis Long, Nathan Bloom, John M. Robinson, D. Standiford, George Mulligan, Milton H. Smith, John Roberts, Edward Wilder, Phil Judge, Charles Jacob, James Trabue, W.F. Harris, Dr. A.J. Brady, T.L. Burnett, William Cromey, R.T. Scowden, Adolph Schmidt, J. Banks McIlvain, John B. Smith, Dr. John Goodman, G.C. Breed, Dr. Turner Anderson, J.E. Marshall and Thomas Hargis.

The funeral was attended by the Louisville police and fire departments, the General Council, city officials, the Louisville Gas Company directors and the employees of Baxter's store and foundry. Several members from other foundries were also present. After the church service, his body was escorted to Cave Hill Cemetery and laid to rest. He is buried in Section A, Lot 104.

THE FRANTZ FAMILY

Tanned Leather

L ouisville tanneries were known throughout the country as the largest manufacturers of oak-tanned leather in the United States and became an important part of the commerce of the city of Louisville. The Frantz family were pioneers of oak-tanned leather manufacturing.

David Frantz Sr. was born on August 30, 1810, in Finstenen, Alsace-Lorraine, which at that time was a part of Germany. He was the youngest of thirteen children. His oldest brother fought in the Napoleonic wars and fought under Napoleon at Waterloo. He had a public education. In 1829, David immigrated to America and arrived in Baltimore, Maryland, where he found employment. In 1831, accompanied by his brother, Peter Frantz, he walked from Baltimore to Cincinnati, Ohio.[35]

When he arrived in Cincinnati, David joined the firm of A.M. Taylor and Thomas P. Peterman, which was a small tannery and leather manufacturer. He became a foreman of the tannery. During this time, most of the leather made for the southern and western markets was made in either the eastern or northern states. In 1833, David married Christiana Staebler, the daughter of Johnathon Staebler of Cincinnati. David managed to save his money, and in 1847, he was able to buy an interest in the firm. Frantz and Peterman moved to Louisville and began their own tannery in Louisville under the name A.M. Taylor & Company. In 1849, Peterson died soon after the factory was opened, and in 1856, Taylor gave the business to H.W. Taylor; it was continued under the management of Taylor and Frantz until 1866, when Mr. Taylor severed his ties with the company and his son David Frantz

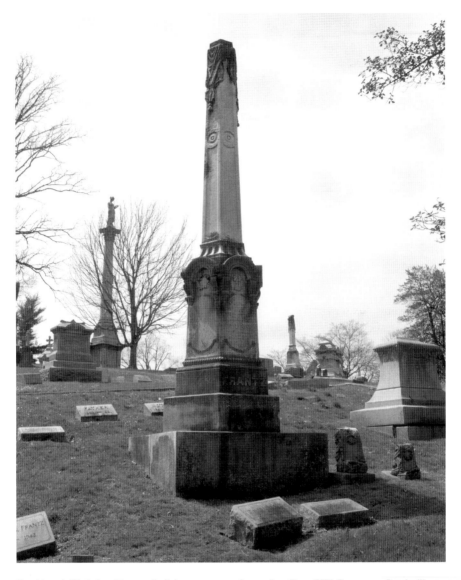

David and Christina Frantz obelisk monument, located at Cave Hill Cemetery, Louisville. *Courtesy of the author.*

Jr. and they ran the firm under the name of D. Frantz & Son. Two years later, his son George W. Frantz, became a member of the firm. In 1885, David Frantz Sr. retired from his business, and his sons continued to run the business. David Frantz's net worth in 1886 was $500,000, or $12,064,635 in today's money. The bulk of his fortune was in bonds, stocks and real estate.

In 1878, David Frantz's wife, Christiana, died, after which he lived alone. David died at his home at 829 East Main Street. When he died on September 14, 1891, he had four children, twenty-six grandchildren and sixteen great-grandchildren. His children were David Jr., George Jr., Mrs. William Hopkins and Mrs. George Merecke. His church was the St. John's German Protestant Church, and his body was buried at Cave Hill Cemetery, Section P, Lot 228. He had an unusual request at his funeral that no flowers be brought.[36] In his will, he left his son George his tanning business on the northeast corner of Franklin and Buchanan Streets, which was valued at $28,000 (or $711,508 today). To his daughter Christina C. Hopkins, he left $12,000 ($304,000 today), which he advanced to her and her husband. To his other daughter, Mary Merecke, he gave $12,000, which was already advanced. To his son David Frantz Jr., he gave $12,000, which was already advanced. George Frantz also received $12,000. To the children of his deceased daughter, Caroline Bauer, he gave $12,000.[37]

George Washington Frantz Sr., the son of David and Christian Frantz, was born on September 6, 1844, in Cincinnati, Ohio. He was only three years old when his parents moved to Louisville. He was educated in the local public schools. After graduating from school, George acquainted himself with the tannery and leather business. In 1866, he married Mary Enderlin and had six children: George W. Frantz Jr., Emma Eugenia, Walter, David, Edwin and W. Harold. In 1885, George Sr. and his brother David Jr. ran the tannery and leather business. His sons George W. Jr., Daniel W., Harold, Walter and Edwin Frantz eventually all became involved in the company. David Frantz Jr. and George Frantz Sr. became interested in the Kentucky Cattle Raising Company and endorsed the company for a large sum of money, after which the company went out of business. When the company went out of business, the leather factory could no longer run. The factory was shut down between 1894 and 1895. With the failure of the Cattle Raising Company and George Sr. taking his brother David to court over the estate, David Jr. decided to quit the business, leaving George to run a plant valued at a $250,000 ($6,758,247 today). When George took over the plant, he made $26,000 worth of improvements, and when they were completed, his plant became one of the largest and best-equipped leather manufacturers in the Southwest.

Although his main interest was in the factory, George Sr. was also a director of the Citizen's National Bank. In 1895, he was elected the Louisville parks commissioner. Unfortunately, he was sued by Morris Belknap, who claimed that George was not a citizen or resident of the city. During the

administration of Mayor Charles Jacob, George served for two years as chief of the fire department. He believed in protective tariffs, which would protect home industries and labor interests, and believed that the American dollar should be worth 100 cents over the world markets. He was a Mason, a member of the Odd Fellows and a Knight of Honor. His sons George W. Frantz Jr., Daniel and Edwin were all members of the firm.[38]

In 1899, George Frantz Sr. was able to free himself from his liabilities incurred by the Cattle Raising Company. In order to restart the tannery, he mortgaged the company for $25,000, and with that money and $5,000 in the bank, he restarted the plant in March 1900 and ran the tannery on a limited basis. He turned out about sixty thousand hides per year but never again ran the tannery at full capacity. The plant made harnesses, collars and leather. In 1902, the unsecured creditors held claim against George for $19,000. There was $14,000 worth of hides in the vats being tanned. The Columbia Finance and Trust Company, which was the trustee, held a $25,000 mortgage on the plant. The plant was valued at $125,000. George's son, George W. Frantz Jr., who was a practiced tanner, was in charge of the plant and asked the creditors to take charge of the business and run the firm.[39] In 1902, with failing health, George Frantz Sr. retired from the firm.

On October 22, 1913, George Frantz Sr. died from blood poisoning resulting from a slight hand wound he had received several weeks before his death. His funeral was held at his home on 2143 Sycamore Street, and he was laid to rest at Cave Hill Cemetery, Section P, Lot 232. George Frantz's home was once a Louisville showplace in Crescent Hill. The mansion had twenty-six rooms. George added a third floor, including a ballroom with gold cornices and a huge plate glass mirror. His house was furnished with marble statues, bisque figures, marble-topped tables, gold mirrors, twelve gas chandeliers and hand-carved beds. His son W. Harold Frantz inherited his father's home and continued to live there. W. Harold Frantz was the last of George Frantz Sr.'s children when he died on October 3, 1959, at the age of eighty. Harold was not in the tannery business and was instead a draftsman for the Southern Bell & Telephone Company. Since there were no living children from George Frantz Sr., the house was put up for auction on December 8, 1959, including all the antiques.[40]

FRANK MENNE

Candy Manufacturer

Frank Menne was born in 1857 in Louisville, Kentucky, and was educated in the local parochial schools. In 1873, he graduated from St. Xavier's College. After his graduation, he became involved in the candy making business, and in 1882, he organized the F.A. Menne Candy Company. At the time, his factory only produced five hundred pounds of candy per year. His plant was originally located on Jefferson Street, near Fourth Avenue.

On December 3, 1891, a fire broke out in his candy factory on 517 West Main Street, and eight people lost their lives, including Barbara Bell, Lulu Kern, Amanda Dickey, Clara Rauch, Anna Luckhardt and Ida Belle Parker, who died of asphyxiation. At the time of the fire, Frank Menne was not in the factory. On December 15, 1891, a jury found the F.A. Menne Candy Company not at fault, and the fire was deemed to be accidental. The jury could not find Menne guilty even though there were no fire escapes present at the factory. The jury stated that every building on Main Street did not have fire escapes, and the fire inspector did not notify Menne to install fire escapes. The thought did not occur to Menne to build a fire escape in his factory. He stated that there were no bars on the windows except in the basement. In the case of Barbara Bell, the jury put the blame on one of the victims, stating that she could have escaped out the rear windows.[41]

In 1902, Frank Menne and his large plant at Wenzel and Main Street consolidated with the National Candy Company and became known as the F.A. Menne Factory. The National Candy Company was incorporated

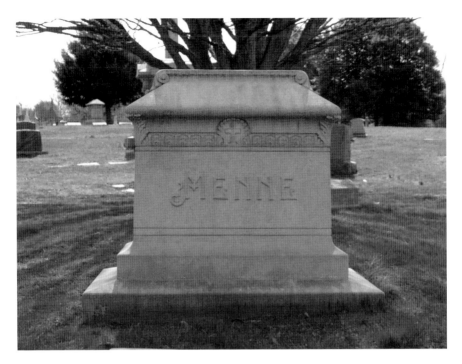

Frank Menne monument at the St. Louis Catholic Cemetery, Louisville. *Courtesy of the author.*

at Trenton, New Jersey, with a capital stock of $9 million. The National Candy Company owned fifteen other factories: one in Cincinnati, three in Buffalo, two in Chicago, one in Minneapolis, one in St. Paul, three in St. Louis, two in Indianapolis, one in Detroit and one in Grand Rapids. The total capacity of all the factories was 100 million pounds of candy each year. Frank Menne received $900,000 in cash and stock for his plant. The Menne factory would produce 10 million pounds per year and would employ 350 workers. His factory would be known for his Eagle brand chocolates. Frank Menne would remain a member of the executive board of the new company and would be the manager of the Louisville branch. Menne's family would be the only stockholders in the newly formed company in Louisville. O.H. Peckham of St. Louis became president of the new factory.[42]

In addition to the factory, Menne had a complete box making establishment. From the box making factory, he turned out his candy to all the larger cities of the South and the West. Under his supervision, his company became the largest candy factory in the city and state.

On March 15, 1915, the paper box factory of the Menne Candy Company, located at 541–43 East Madison Street, was destroyed by fire. The damage was estimated at $30,000 but was covered by insurance. About sixty people, mostly women and girls, were thrown out of work for a short time, until the box plant could be rebuilt. The raw materials contained in the factory caused a massive fire on the third floor, and the roof collapsed. The walls of the building were saved. Three or four carloads of raw material were stored in the basement but were deemed unfit for use became of the water from the firehoses. There were close to thirty thousand candy boxes ready for use on the second floor, and the machinery (valued at $20,000) was turned into junk from the flames and water.[43]

In 1920, Menne announced that the National Candy Company had purchased from the Louisville Gas and Electric Company a lot of two hundred feet square at Fourteenth Street and Broadway in order to build a new $1 million factory for the Menne Candy Company. The new building would be five stories tall, with a basement, and would contain the most up-to-date machinery. Menne would be the new manager of the factory, and the old factory at Wenzel and Main Streets would be abandoned. When the new building opened, another 100 workers were hired, bringing the total workforce to 450. The National Company selected Louisville over two other cities due to the exceptional transportation facilities and the lack of labor disputes.[44]

Ill health forced Menne to retire in December 1921. He spent most of his time at home on Brownsboro Road. He was a member of the Elks Club, Knights of Columbus and the Pendennis Club. He died on February 22, 1922, and was survived by his wife, Katie Menne; three daughters, Mrs. B.F. Coggins, Mildred Menne and Mrs. Charles Evans; and three brothers, B.L. Menne, Clifford Menne and Edwin Menne. His funeral was held at Rome Catholic Church, and he was buried at St. Louis Cemetery.[45]

When he died, Menne left an estate worth $500,000 ($12,326,200 today). Almost $470,000 was in the form of stocks and bonds. The money was left in a trust for his wife, Katie. His children were to share the estate after his wife passed away. St. Joseph's, St. Thomas and St. Vincent's Orphan Societies; the St. Lawrence Institute for Working Boys; and the Particular Council of the St. Vincent de Paul Society were each receive $250. The Sisters of the Good Shepherd was given $500. The Home of the Aged and Poor received $750, and $2,000 went to the St. Frances of Rome Church.[46]

JOHN P. MORTON

Publisher

J ohn P. Morton's father was a prominent merchant and businessman from Lexington, where John was born in March 1807. He was educated at the Joseph Lancaster School at Lexington, and at the age of sixteen, he entered Transylvania University in Lexington. Unfortunately, his father declared bankruptcy, and John had to come home from school and find a job. He decided to go into the bookstore business and acquired a position as a clerk in a Lexington establishment. When William W. Worsely started the Louisville Bookstore, on Main Street, he hired John Morton as a manager of the store. In 1829, when the bookstore decided to publish books, the name was changed to Morton & Smith. The firm also published a daily newspaper called the *Focus of Politics, Commerce, and Literature*, which was later changed to simply the *Focus*. In 1832, the paper merged with the *Louisville Journal* into the *Focus-Journal*, with George Prentice as the editor. The paper was the founder and parent of the *Louisville Courier-Journal*.[47]

Morton & Smith went into the publishing business on a large scale and became popular and prominent in the South. The firm was the rival of the great publishing houses of schoolbooks of New York and Cincinnati. Works from Morton & Smith were used exclusively throughout the South for fifty years. The business expanded and prospered, extensions were made and the firm was known as one of the leading houses of the Union. In 1838, Morton and his brother-in-law, Henry Griswold, opened a book, stationery, printing and binding business and changed the name to Morton & Griswold. The firm was located on Main Street, between Fourth Avenue and Fifth Street.

In 1858, the company changed its name to John P. Morton & Company and was known as one of the leading and most progressive publishing houses in the country.

John P. Morton & Company was a pioneer establishment in the publishing of schoolbooks in the South. At the time, the company was the only firm of its kind south of the Ohio and Potomac Rivers. It was also the first firm to publish a book in electrotype in a southern state. The first of its published books was the "Series of Readers." There were six of them, known as *Goodrich Readers* and edited by Noble Butler, who was one of the best-known scholars and most accomplished teachers in Kentucky. The public schools of Vicksburg, Mississippi, adopted the schoolbooks.[48]

The company also published *The Grammars*, written by Noble Butler, which were used throughout Mississippi, having been adopted by the Mississippi State's Teachers Association. The firm also published *The Series of Mathematics* by Professor T.B. Towne and related to the series of books published by Morton called *Practical Arithmetic and Algebra*. The entire series of books was the most complete series published in the United States on mathematics up to the point. The books were used in New Orleans and at both public and private schools in Mobile; Jackson; Vicksburg; Meridian; Columbus; Aberdeen; Augusta, Georgia; Macon, Mississippi; Macon, Georgia; and Louisville and Lexington, Kentucky. The firm also published a *Manual of Composition*, written by John Bonnell, DD, who was the president of Wesleyan Female College of Macon, Georgia. In 1874, the company published Noble Butler's *A Practical and Critical Grammar of the English Language* and, in 1875, George Frederick Baker's *Text-book of Elementary Chemistry*. The company also published *The Western Farmer's Almanac*.[49]

Toward the end of his life, Morton gave up the details of the business to his nephews and Henry Griswold.[50] With his massive amount of wealth, he entered into the railroad business and other businesses, including orange groves and town real estate in Florida. He eventually sold his bonds in the Short Line Railroad and gave $100,000 for the founding of the Episcopal Orphanage and Infirmary, which was built on Morton Avenue in the Highlands of Louisville. The name was changed to Morton Memorial Infirmary, but according to his wishes, the name was later changed simply to Church Home. The Church Home operated until the latter 1970s, when in 1977 a new facility was built on Lyndon Lane. John Morton was one of the first and oldest members of the Christ Church Cathedral on Second Street in Louisville.[51]

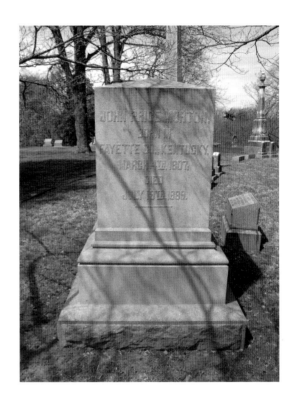

This page: John P. Morton monument located at Cave Hill Cemetery, Louisville. *Courtesy of the author.*

During winters, Morton spent his time in New Orleans and the western coast of Florida at his large estate. Eventually, he was brought back to Louisville and spent the last days of his life at his home on Eighth Street. He died at the age of eighty-two. He had married Harriet Griswold. Morton was one of the wealthiest citizens in Louisville, and when he died on July 20, 1889, he left an estate worth between $750,000 and $1 million (approximately $24,613,670 today) and control of the one of the great publishing firms. His funeral was held at the Christ Church Cathedral, and he was buried at Cave Hill Cemetery, Section N, Lot 205. Eight of his nephews transported his body to Cave Hill Cemetery: W.G. Munn, Marshall Morris, Hamilton Griswold, Samuel Munn, J.T. Cooper, Howard Griswold, William Morris and Alexander Griswold. His honorary pallbearers were R.T. Durrett, George Morris, Arthur Peter, John M. Robinson, Morris Belknap, John A. Carter, Thomas Barrett and R.C. Hewitt.

When his will was finally settled in 1896, in the state Court of Appeals in the Common Pleas division, with Morton's executors set against Morton's heirs, the judge settled that the Church Home for Female and Infirmary for the Sick was bequeathed $65,000. In 1905, the heirs of the Griswold and Morton estates consented to sell the property on Main Street between Fourth Avenue and Fifth Street to Colonel Reuben Durrett for $50,000. The John P. Morton publishing house would continue to rent the property for the printing and publishing business. Morton & Company continued to publish *The Western Farmer's Almanac* until 1943, and on April 1, 1944, the family decided to close the doors on the Morton & Company publishing house when there were no male heirs left to take over as president.

RICHARD A. ROBINSON, JOHN M. ROBINSON AND WILLIAM MEADE ROBINSON SR.

Wholesale Dry Goods and Wholesale Pharmacy

RICHARD ALEXANDER ROBINSON

The wholesale drug trade of Louisville was among the largest of the city's mercantile interests. Richard Alexander Robinson & Company was one of the representative businesses that reached not only the Ohio but also the Gulf and penetrated all portions of the interior of the United States. R.A. Robinson was born on October 23, 1817, on Spring Hill Farm, near Winchester, Virginia. He was the son of Lyles Robert and Catherine Worthington Robinson. He received his education at Winchester Academy, and in 1832, his father secured him a position with Baker Tapscott, who was a leading merchant in Shepherdstown, Virginia. His mother died in 1828, and his father died in 1834, leaving a family of orphans. Richard was only seventeen years old when his parents died and was the oldest of his siblings. The orphaned children went to live with different relatives in Maryland and Virginia.

Richard decided to move out west in order to secure an income to the point that he could reunite his family. Several of his friends had moved to Louisville, Kentucky, including his friend Arthur Lee. In 1837, Richard arrived in Louisville and became a bookkeeper in a wholesale grocery store, but the financial panic of 1837 forced the store to go out of business and Richard had to seek other employment. He was hired as a bookkeeper in the

firm of Casseday & Ranney, working until 1841, when he went into business for himself. In the meantime, he brought his brothers Goldsborough and Archibald to Louisville. Along with his brothers and Arthur Lee, they formed the firm of Robinson, Lee & Company. They engaged in the retail dry goods business on Market Street.[52] Not too long after, Arthur Lee passed away, and Richard changed the name to Robinson & Brothers.

In 1842, Richard married Eliza Pettet, the daughter of William F. and Mary Pettet, of Louisville. They had seven sons, all of whom became prominent merchants. Soon after his marriage, all five of his brothers came to Louisville.

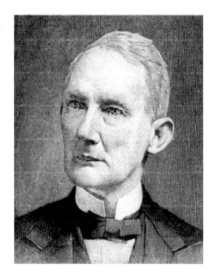

Richard Robinson portrait. *From Allison's* The City of Louisville and a Glimpse of Kentucky *(1887).*

The same year he was married, Richard broke his connection with the dry goods firm, transferring all his interests to his brothers, and decided to go into the retail drug business on Market Street in the firm of James George and Arthur Peter. The business remained on Market Street until 1846, when the name was changed to Robinson, Peter, and Carey; the business soon expanded to Market Street. In 1855, the business partnership was dissolved. R.A. Robinson took the wholesale portion of the company and changed the name to R.A. Robinson and Company, and Mr. Carey took the retail portion of the business. In 1869, Robinson bought the building on 219 West Main Street for his business, which had five floors and a basement. He also owned three floors and a cellar on Sixth Street, between Main Street and the Ohio River, which was used for a laboratory and warehouse. His central point for the business was on Main Street. His main building comprised six floors, which extended from Main Street to Nelson Streets and were filled with thousands of items needed for a wholesale druggist. There was also a warehouse on Sixth Street.

Inside the warehouse were brushes, combs, cosmetics, soaps, perfumes, toilet goods and surgical instruments. In the rear of the warehouse were drugs, drugs and more drugs. There were oils, essences, powders and roots. The principal sales for his wholesale items were in Kentucky, Southern Indiana, Tennessee, Alabama, Mississippi, Georgia, Arkansas and Texas. He

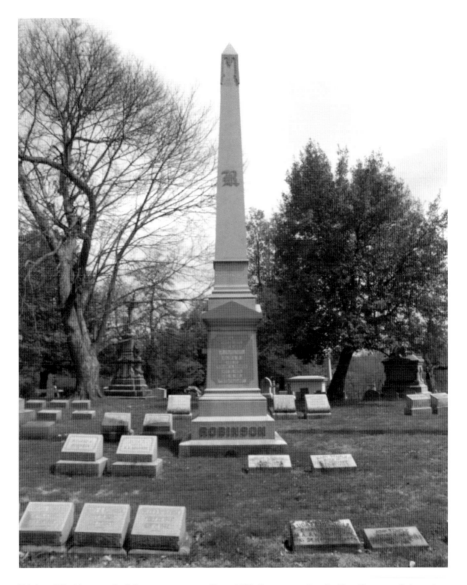

Richard Robinson obelisk monument at Cave Hill Cemetery, Louisville. *Courtesy of the author.*

also exported his goods to Europe. His business became one of the largest wholesale drug firms in the Southwest.[53]

In 1878, in order to open avenues of trade for his sons, Richard established the wholesale hardware firm of Robinson and Brothers and Company, and a little later he formed a joint stock company with a capital

Richard Robinson building. *From Elstner's* The Industries of Louisville, Kentucky and of New Albany, Indiana *(1887).*

of $200,000 to operate the Louisville Cotton Mills. He later increased the operating capital to $300,000. He also established the Union Lime and Cement Company with a capital of $450,000. For six years, he was the director of the Louisville & Nashville Railroad Company, and for five years, he was director of the Elizabethtown & Paducah Railroad Company. He was also director of the Louisville Bridge Company and was director and vice-president of the Falls City Bank. In 1882, the Louisville Board of Trade made him an honorary life member of the board, which was the first time in the history of the organization.[54]

With his money, Richard was charitable to both religious and educational institutions. He gave the endowment for a scholarship to Theological Seminary of Virginia for the education of Episcopalian ministers and endowments of $5,000 each to the Louisville Charity Organization Society, the Home for Friendless Women, Home of the Innocents, the Orphanage of the Good Shepherd and the Young Men's Christian Association. To the

Protestant Episcopal Orphan Association and the John M. Norton Memorial Infirmary, he gave even larger contributions and was one of the benefactors for the building of St. Andrew's Episcopal Church in Louisville.[55]

In 1894, he purchased and presented to the Shenandoah Valley Academy, which succeeded the academy at Winchester, a tract of twenty acres of land adjoining the academy, on which a $12,000 permanent home was built. He also permanently endowed a scholarship at the academy and gave enough money to secure the academy's prosperity.[56] The Shenandoah Valley Academy continues in operation to this day and is located in New Market, Virginia, as a private coeducational boarding high school.

On December 10, 1897, suffering from pneumonia, Richard Robinson died at his residence on 1104 Fourth Avenue. He left six sons: William, Worthington, R.A. Robinson, Archibald, Arthur Lee and Charles Robinson. His brother-in-law was Charles Pettet. He was buried in Cave Hill Cemetery, Section A, Lot 199.

John M. Robinson was the brother of Richard Alexander Robinson and was the youngest of the five brothers. He was born on September 24, 1824, in Winchester, Virginia. When his parents died, he was an orphan. He lived with his uncle, Dr. Henry Boteler, in Shepherdstown, Jefferson County, Virginia. He attended the local schools in Shepherdstown, and after receiving his education, he moved to Lancaster, Pennsylvania, to become a clerk in the dry goods store of J. Newton Lane, who taught John the business trade. In 1841, his brothers brought John to Louisville, arriving when he was seventeen years old and working as a clerk in his brothers' dry goods store. Three years later, his brother Goldsborough Robinson died, and at the age of twenty, John took his brother's place as a partner in firm of Robinson & Brothers. His brother R.A. Robinson, who was a wholesale druggist, opened his own dry goods store on Fourth and Walnut Street. In 1848, John and his brother William Meade Robinson opened a wholesale dry goods store on Main Street under the name J.M. Robinson Company.

The business continued to expand and grow into southern states, but when the Civil War broke out, all trade with the South came to a halt; Robinson along with other wholesale merchants took a heavy loss during the war. After the war was over, his company pushed its dry goods into new territory, and the business again took a prominent role among the dry goods firms in the Southwest. After forty years, the business had expanded to where Robinson could build a new store on Sixth and Main Streets in Louisville. In 1893, the firm changed its name to J.M. Robinson, Norton, and Company when George Norton became a member of the firm. John's sons Booker and

Alexander Robinson also joined the firm. His first marriage was to Ellen Boyd Anderson, the daughter of Colonel Thomas Anderson of Louisville, who died in 1847. In 1848, he married Maria Louise Booker, the daughter of Judge Paul Booker and Letitia Wilcox Reed Booker of Springfield, Kentucky. He had seven children: Mrs. Carvin Bell, Mrs. William Bridgeford, Mrs. Gilmer S. Adams, John Robinson Jr., P. Booker Robinson, Alex Robinson and Reda Robinson.[57]

John M. Robinson was a trustee for the Church Home and Infirmary, Norton Infirmary, Orphanage of the Good Shephard, Home of the Innocents and Trinity Hall School. He was director of the Merchants National Bank, the Kentucky Wagon Company, Mutual Life Insurance Company and the Louisville Trust Company.

John had suffered from illness of his lungs and kidneys. His doctors suggested that he travel to the South. On January 26, 1894, he traveled to Thomasville, Georgia, and stayed for about three weeks with his wife and daughter. Unfortunately, his health did not improve, and he was taken back to Louisville in the private railway car of President Milton Smith of the Louisville & Nashville Railroad. He died on March 17, 1894, and black crepe was placed on the doors of Robinson, Norton and Company, R.A. Robinson & Company, Bridgeford and Company and the Louisville Trust Company. He died from lung and kidney problems. His funeral was held at Christ Church Cathedral on Second Street in Louisville, Kentucky. Thousands of mourners, including the employees of Robinson, Norton and Company, packed the cathedral, and many of the mourners had to stand outside the church. He was buried in Cave Hill Cemetery, Section F, Lot 481.[58]

Robinson was very fond of baseball, and when he saw a boy staring through the cracks of the fence to watch a game, he would pay for the boy to enter the ballpark and watch the game. He was laid to rest at Cave Hill Cemetery. In his will, he left his home on Fourth Avenue, between Broadway and Breckinridge, including all the household items in the house, to his wife. She also was the beneficiary of his life insurance. He also had two life insurance policies for his two daughters: Ellen Bell and Madelein Bridgeford. He also left behind one-sixth of his interest in the J.M. Robinson, Norton & Company, and the remainder would be divided equally among his children.

William was one of the five Robinson brothers. He was born in Winchester, Virginia, on October 9, 1826. He was educated in Shepherdstown, Virginia. His brother Richard brought William to Louisville, and in 1848, he entered into business with his brother John in establishing the dry goods store of

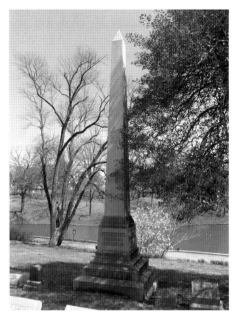

Right: John M. Robinson obelisk monument at Cave Hill Cemetery, Louisville. *Courtesy of the author.*

Below ; John M. Robinson building. *From Elstner's* The Industries of Louisville, Kentucky and of New Albany, Indiana *(1887).*

Robinson & Brother, which later changed its name to Robinson, Norton & Company. He was married in Washington, D.C., on October 29, 1849, to Anne Mason Bonnycastle, of Virginia, who was the daughter of Professor Charles Bonnycastle of the University of Virginia and Anne Mason Tutt of Loudoun County, Virginia. William died on November 26, 1858, and was buried at Cave Hill Cemetery, Section G, Lot 147. He was a member of the of St. Paul's Episcopal Church. He was only thirty-two years old. He left two children, Charles Bonnycastle and William Meade Robinson Jr.[59]

Captain William C. Hite and Captain William W. Hite

Steamboats

William Chambers Hite belongs to five generations of Hites who settled in this county. The Hite family dates back to the early exploration of Kentucky. Isaac Hite belonged to a party of men that came to the Falls of the Ohio on an exploring expedition. Daniel Boone was a member of the same party. Hite returned to Virginia after the expedition, but in 1778, he came back to Kentucky and settled in Jefferson County. In 1782, his brother Abraham, a captain in the American Revolution, also moved to Kentucky. Another brother, Joseph Hite, followed his brothers into Kentucky. Both Abraham and Joseph were killed by Indian raids.[60]

Captain William Chambers Hite was born near Middletown, Jefferson County, Kentucky, on July 23, 1820. His parents were Lewis and Eliza V. Hite. William spent the first eleven years of his life on a farm. His farmer father died when William was only a small boy, and what property was owned by the family was swept away by debts after his death. Hite's mother moved to Louisville. He received a limited education before entering the workforce. When he was thirteen years old, he began work to help his mother. He worked as a clerk, first in the store of Forsythe & Riddle and later with David L. Adams. During his free time, he became self-educated and mastered the branches he thought would aid him in business. He managed to save a small amount of money from his work as a clerk. He worked for a carpet company of Hite, Small & Company. His oldest brother was Lewis Hite, who was the senior member of the firm. His brother died, and William became a partner in the firm.[61]

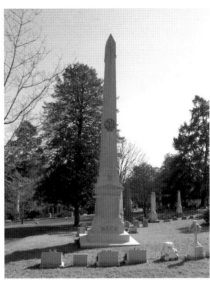

Left: William Hite. *From Johnston's* Memorial History of Louisville from Its First Settlement to the Year 1896 *(1896)*.

Right: William Hite obelisk monument at Cave Hill Cemetery, Louisville. *Courtesy of the author.*

William became acquainted with all the river men in Louisville and was offered a position as a clerk on the steamer *Alice Gray* under Captain Frank Carter; later he became a clerk on the steamer *Talma* under the command of Captain Edward T. Sturgeon, and in 1846 he was master of the *Talma* for one season. William quit the carpet business and accepted the new position as clerk and later captain of the *Peytona*.

In 1856, William purchased an interest in the Cincinnati Mail Line Company with Captains Sherley, Sherlock and Thompson. A little later, he made an investment in the Henderson and Evansville Packet Line. In 1861, he quit his position as clerk on the river and accepted the responsibility as cashier in the Commercial Bank, at the corner of Bullitt and Main Streets, and remained with the bank until 1873. He almost lost his life in a confrontation with Edmund Bainbridge. Hite had joined the Mail Line Company, and Bainbridge thought that he had an injustice imposed on him by Hite; a quarrel ensued between them when Bainbridge placed a large rock in a handkerchief and struck Hite over the head, fracturing his skull. For several weeks, Hite was in the hospital wavering between life and death. Eventually, he recovered, and when he became well enough, Hite continued his connection with Packet and Mail Line Companies,

Close of William C. Hite obelisk monument at Cave Hill Cemetery, Louisville. *Courtesy of the author.*

increasing his interests. He was vice-president of the Pullman Southern Car Company. Captain Hite was also elected president of the Henderson Packet Company.[62]

He became a director of thirteen different corporations, including the Southern Mutual Insurance Company, of which he was the founder; the Kentucky and Indiana Insurance Company; the Louisville Cement Company; Northern Lake Ice Company; the Bank of Kentucky; the Birmingham Rolling Mill Company; Louisville and Jeffersonville Ferry Company; and the Louisville and Evansville Mail Company. He also a board member of Cave Hill Cemetery Company; Franklin Insurance Company; Louisville & Nashville Mail Line Company; Louisville and Cincinnati Mail Line Company; Louisville Gas Company; University of Louisville; Pullman Southern Car Company; Union Insurance Company; and Christ Church vestry. He was also a large stockholder in various steamboats.

In 1851, he married Mary Rose and had five children: Mrs. G.A. Winston, William W. Hite, Nannie, Lewis and Allen. In November 1882, Hite was visiting McKnight's carpet store to buy carpet for a boat he was getting ready for launch. Captain Hite and several of his friends entered the elevator for the purpose of reaching the third floor, and when the elevator reached about thirty-five feet, the rope holding the elevator broke and went crashing to the basement floor. Hite received a compound fracture to his left leg, near the knee, and a simple fracture to his right ankle. He was

taken to his residence at Second and Walnut Streets, where one of the best physicians in Louisville, Dr. David Yandell, and several other physicians came to his bedside. He seemed to recover slowly for about three weeks, but he suffered from blood poisoning. On December 6, 1882, Hite could no longer hold on to life and passed away. When news reached Louisville of his death, all business around the river came to a stop, and flags on all steamers at the wharf were placed at half-staff. His funeral was held at Christ Church Cathedral in downtown Louisville. He was laid to rest at Cave Hill Cemetery, Section B, Lot 81.[63]

Captain William W. Hite was born in Louisville on November 16, 1854. He received his education from the local schools and attended a private school under Professor B.B. Huntoon. He completed his schooling at McGown's Military Academy in Anchorage, Kentucky. In 1872, at the age of eighteen, he was employed at Joseph T. Tomkins as a clerk. He remained with the business until 1877, when he became a secretary and treasurer of the Louisville & Evansville Mail Company. In 1878, he became a member and later junior partner of Gilmore, Hite & Company, steamboat outfitters and suppliers in steamboat, railroad and mill supplies. In 1882, he reorganized the company, became president and renamed the company W.W. Hite & Company.[64] The company was located on 146 and 148 Fourth Avenue, between Main and the Ohio River. Hite & Company owned a controlling interest in the Louisville and Evansville Packet Company, running the elegant line of freight and passenger steamers, which included the steamers *City of Owensboro*, the *Rainbow*, the *James Guthrie* and the *Carrie Hope*, which made stops at Louisville, Owensboro, Evansville and Henderson. Hite & Company also represented extensive lines of trade with the Boston Belting Company in rubber goods; the Asbestos Packing Company, of Boston, in asbestos; Samuel Cabot of Boston in creosote stains; the New York Tar and Chemical Company, of New York, in two- and three-ply Ready Roofing; and the Magnesia Sectional Covering Company, of Philadelphia, in pipe covering, sockets sheathing paper, roof coating, paints and so on.[65]

One year later, William became a director in the Mutual Life Insurance Company of Kentucky and was made director in the Bank of Kentucky and of the Louisville Gas Company and vice-president of the Louisville & Cincinnati Mail Line Company.

In 1888, he married Carrie Pace of Richmond, Virginia, and had one son, W.W. Hite. He purchased a home on Newburg Road. For twenty years, he was chairman of the River Committee from the Board of Trade and

Left: William W. Hite. *From Johnston's* Memorial History of Louisville from Its First Settlement to the Year 1896 *(1896)*.

Below: Louisville to Evansville mail packet steamboat owned by William C. Hite. *From Elstner's* The Industries of Louisville, Kentucky and of New Albany, Indiana *(1887)*.

helped to improve the channel. He eventually served one term as president of the Board of Trade. He was director of the organization for twenty-six years. In 1883, he became president of the Louisville and Evansville Mail Line, a packet company operating steamboats between the two cities. He was also president of the Louisville and Jeffersonville Ferry Company and vice-president of the Louisville and Cincinnati Packet Company. He was considered the last of the great river men.

William had also been director of the Bank of Kentucky since 1890 and was a considerable stockholder in the bank. He also served as colonel on the

governor's staff, having been appointed to that position by Luke Blackburn during his administration. In 1889, during his administration as mayor, Charles Jacob appointed Hite as supervisor of the Industrial School of Reform, and in 1892, he was elected vice-president of the institution. In 1884, he was made a director of the Southern Exposition. He was also a member of the Pendennis Club.

On July 3, 1908, he died at this home in Newburg from Bright's disease. He is buried at Cave Hill Cemetery, Section B, Lot 81.

CHAPTER 8
MICHAEL MACDONALD MULDOON

Monuments

Michael Muldoon was born in Kingscourt, County Cavan, Ireland, on August 13, 1836. He came to America when he was a young man, and in July 1854, he settled in Louisville and established the Muldoon Monument Company at 318–20 West Green Street. He learned the stonecutters trade in Ireland and went into the business of erecting monuments. His work was of the highest quality, and for fifty years, he built more monuments to distinguished citizens than any other man in America. His company was the largest monuments works in the United States.[66]

Muldoon made many trips to Europe, maintained a studio in Carrara, Italy, and employed several workers. A chapel erected to the late General D.D. Colton, in the cemetery at San Francisco, was made entirely by Muldoon's employees at Carrara and was shipped around Cape Horn and put up by Muldoon & Company at a cost of $46,000. Muldoon owned an interest in some quarries at Barre, Vermont, where he obtained gray granite. He also used red granite from the Hill o'Fare, in the north of Scotland. The stone was all worked into shape at the quarries, and the only work done at the warerooms and yards in Louisville was the polishing and lettering. For large contracts, Muldoon never brought the stone to Louisville at all. In the Louisville yards and warehouse, he employed between forty-five to fifty men, who were constantly busy in finishing the works. His business amounted to $225,000 to $300,000 per year in monuments alone. He also did a business in fine art marbles. He employed many different sculptors and designers, including Carl Rohl-Smith, who after leaving Louisville became one of the most famous sculptors in the East.

Left: Michael Muldoon. *From Allison's* The City of Louisville and a Glimpse of Kentucky *(1887).*

Right: Muldoon monument at Cave Hill Cemetery, Louisville. *Courtesy of the author.*

Muldoon was very successful in obtaining contracts for important pieces of work over some of the largest dealers in the United States. He erected a monument to Harrison Phoebus, the builder and owner of the Hygeia Hotel of Old Point Comfort. The monument was placed at Hamton. He also erected a monument to John C. Calhoun in St. Michael's churchyard in Charleston, South Carolina. He was also contracted by the Odd Fellows to build a monument to their late grand secretary, James Ridgely, in Harlem Square, Baltimore. The monument cost $23,000. He was in competition with twenty other designers for that project. He also designed for the cemetery in Fredericksburg, Pennsylvania, a monument for the son of philanthropist James Lick of California. He designed the Reuben Springer monument in Cincinnati, and in the same cemetery, he built one other monument. He had work done in several of the cemeteries in Pennsylvania. In Kentucky, he built monuments in every town and city. The Confederate monument built in Cynthiana, Kentucky, was erected by Muldoon, and some of his monuments are also found at Frankfort. In Lexington, there are the Breckinridge monuments and the monument to Confederate soldiers. In Nashville, he built the large Cheatham Chapel and built monuments dedicated to C.A.R. Thompson, J.K. Morris and others. At Memphis, he built the Confederate

soldiers monument and the Clergymen's monument. He designed and built Confederate soldiers monuments in Columbia, Tennessee; Columbus, Georgia; Macon, Georgia; Sparta, Georgia; and Thomasville, Georgia. Muldoon has even done work in Texas. He built a large sarcophagus in St. Louis. In San Francisco, there are several of his monuments.

He also built several monuments in New York's famous Greenwood Cemetery, including his last work, which was the erection of a mausoleum over the grave of John W. Mackay, which cost more than $250,000. The millionaire's family gave Muldoon complete authority to build the monument from his own design and did not stipulate a cost. The monument was said to be the most beautiful such work in the United States. He molded the main lines after those in the Church of the Madeleine in Paris, France. He went to Italy, Ireland and Scotland to obtain the best marble and granite for the interior. The Confederate soldiers monument that was located near the University of Louisville campus, across from the Speed Art Museum, and is now located in Brandenburg, Kentucky, was built by Muldoon, although the bronze figures were done by Enid Yandell. He also built numerous monuments in Cave Hill Cemetery and other cemeteries located throughout the country in the South, East and Midwest.[67]

Muldoon married Alice Lithgow, daughter of James Lithgow, who was mayor of Louisville. They had four daughters: Anita Muldoon, a well-known singer; Mrs. George Norton; Mrs. Byron Hilliard; and Hannah Muldoon.[68] He was once park commissioner. He was a friend of John B. Castleman, who was also a park commissioner. He built Louisville City Hall. The contract went to him and his brother-in-law, Jacob Smyser. He also had interests in the American Car and Foundry Company at Jeffersonville, Indiana. Jacob Smyser controlled the company when it was formerly known as the Ohio Falls Car Company.[69]

On April 27, 1911, Muldoon died at the age of seventy-five at his home at 1016 Cherokee Road. The funeral was held at his residence, and he was buried at Cave Hill Cemetery, Section 1, Lot 76. His Celtic cross at Cave Hill Cemetery stands thirty feet tall and is one of the finest cross memorials in the world. His company still continues to operate to this day. The company is now known as Muldoon Company and is located on 808 East Broadway. The company is considered Kentucky's oldest and largest memorial provider.

WILLIAM B. BELKNAP SR., WILLIAM R. BELKNAP JR. AND COLONEL MORRIS BELKNAP

Hardware Wholesalers

W illiam Burke Belknap was the son of Morris Belknap, a well-to-do iron manufacturer. His mother was Phoebe Locke Thompson. On May 17, 1811, William Burke Belknap was born in Brimfield, Massachusetts. When he was five years old, the family moved to Pittsburgh in 1816. Morris made a profession in the furnace and rolling mill industry business and became a pioneer in the city's iron industry. William Belknap was educated at the school in nearby Allegheny, Pennsylvania. At an early age, William had an innate business ability. His father left him when he was seventeen years old. William managed the business affairs in Pittsburgh while his father accompanied Theodore Yateman to inspect the mineral fields in Tennessee. His father was so impressed with the coal iron deposits on the Tennessee and Cumberland Rivers that he decided to build a furnace in Stewart County and made his home there. He told William to sell his interests in Pittsburgh and purchase and ship to his father's landing the equipment necessary to build a furnace. In the spring of 1828, William set out with his family to join his father. At Louisville, William had no choice but to unload the material for the furnace from the Falls of the Ohio to Shippingport. The material for the furnace arrived, and it was built three miles from the river at Stewart County. For two years, William helped run the business.[70]

In 1830, at the age of nineteen, William gained permission from his father to make a life for himself. He mounted his horse and settled in Mills Point, Hickman County, Kentucky. William set up a mercantile business in town.

William B. Belknap monument at Cave Hill Cemetery, Louisville. *Courtesy of the author.*

Elias Walton and Henry Lonsdale were two young men from Louisville who brought with them a large stock of goods and started a large trading business. William became a partner with the two young men and was given a branch in Moscow, Kentucky. Later, a third branch was established in Vicksburg, Mississippi. His associates shipped large quantities of grain south. Belknap suggested that they ship shelled corn instead of sending corn still on the cob and in bulk. The business was successful, and Belknap decided to withdraw from the partnership, but before he could cash out his part of the business, the panic of 1837 struck and the business went bankrupt. His poor health forced him to leave Mills Point. He traveled to Texas, St. Louis, Cincinnati and Louisville looking for a better location, and by April 1860, he had decided to make Louisville his new home.[71]

On April 1, 1840, he became an agent and opened an iron store for a Pittsburgh iron and nail house that was operated by George and John Shoenberger. The store was located on Third and Main Streets. For years, Belknap's store was the only iron house in the city and had exclusive control in the market of nails, bar iron and boiler plate. On May 30, 1843, he

married Mary Richardson, the daughter of William Richardson, president of the Northern Bank of Kentucky.[72]

When the Civil War broke out in 1861, he gave up the business in order to devote himself to his own growing trade. During the war, William was a supporter of the Union cause and fed and entertained Union officers in his home, including Generals Ulysses S. Grant and William T. Sherman. He was one of the first members of the City Sanitary Commission during the Civil War, but when the federal government took over the Sanitary Commission, he lost all interest and gave up his connection with the organization. In 1849–50, with Captain J.C. Coleman, Lewis Ruffra and William Stewart, William purchased the Louisville Rolling Mill, completed the mill and put it into successful operation, the first mill of its kind in the city of Louisville. Soon afterward, Belknap established his own iron and hardware business, the firm of W.B. Belknap & Company, with his brother, Morris Locke Belknap, as a partner in the business.[73]

By 1865, the Belknap Company was operating at two locations. The first was at 83 West Main, which sold blacksmith tools, springs, axles and several varieties of scales. The second shop was located at Third and Main Streets and sold iron and sheet items, nails and horseshoes. By 1874, the business, which included William and Morris along with their brother-in-law, Charles J.F. Allen, and William's son, William Richardson Belknap, ran the company at 113 and 115 Main Street. On June 1, 1880, the company was incorporated and expanded along Main between First and Second Streets, becoming a wholesaler of hardware. The business carried merchant iron, a stock of two thousand tons of ordinary bar, Swedes iron and sheet iron of all gauges and grades (including galvanized), along with various grades and kinds of steel. The business also acted as agent for Crescent cast steel, which was used by railroads and machine shops. It also included nuts, washers, bolts, lag screws, bolt ends, boiler rivets, tank rivets, anvils, drills, bellows, portable forges and everything that goes into fitting a shop complete for foundry men or blacksmiths. It also carried corrugated iron for buildings. It had a complete stock of sheet iron for tinners. It carried ammunition and shot. It also carried builder's hardware, including carpenters tools. The company became the second-largest manufacturing hardware company in the United States.[74]

William Burke Belknap was one of the first promoters of the Mercantile Library and was a supporter of numerous other institutions. He was director of the Southern Bank and was president of the bank when it changed its name to Citizens National Bank. He lived in Pee Wee Valley and had five

children, with one child dying in infancy. His remaining children included Mrs. C.F. Allen, Lucy Belknap, William R. and Morris. He died on February 24, 1889, at the home of his son William R. Belknap at 917 Fourth Avenue. His funeral was held at his home. He was seventy-nine years old when he died. He was buried in Cave Hill Cemetery, Section N, Lot 209.

When William Burke Belknap passed away, the company went to his son William R. Belknap, who was acting president of the company. William was born on March 25, 1849. He was schooled under Reverend Stuart Robinson and Professor Benjamin Harney, who ran their school from the basement of the Presbyterian church on Third Street, between Walnut and Green Streets. He later entered Male High School and graduated in 1866. He entered the scientific department at Yale University and obtained a Bachelor of Science degree in 1869. He then studied for an additional year at Yale. He studied natural science and botany under Professor D.C. Eaton, zoology under Professor A.E. Verrill and economics under Professor D.C. Gillman. After graduation, he spent a year traveling Europe. In 1874, he returned to Louisville and joined his father's hardware business, which was one of the largest manufacturing hardware stores in the West.[75]

When the firm was incorporated in 1880, William R. Belknap became vice-president, and two years later, he was president. William R. expanded the business to become a supply house to consumers and retailers. He advertised revolvers, rifles, ammunition, hunter's clothing and even church bells. In 1903, he changed the name to Belknap Hardware & Manufacturing Company Inc. and began to manufacture horse collars. His company expanded to a warehouse and display space covering forty-two acres inside fourteen buildings. His selling strategy was to make the process of buying everything a rural customer needed at a wholesale price in one place. He retired when William Heyburn was made president of the company. He continued as chairman of the board of directors for the company.[76]

William was also director of the Louisville Board of Trade and served one term as president of the Louisville Commercial Club. He was on the Board of Directors for the Southern Exposition and was a strong supporter of the Presbyterian Black Missions in Louisville. He was also involved with Eastern Kentucky and Berea College in the administration of the college and was one of the directors. He personally gave $25,000 to help build the Young Men's Christian Association on Third Street and Broadway, and $375,000 was raised in a campaign to complete the project. He was also in the early stages for a campaign to raise $300,000 to build the Young Women's Christian Association. He personally gave a donation of $3,000

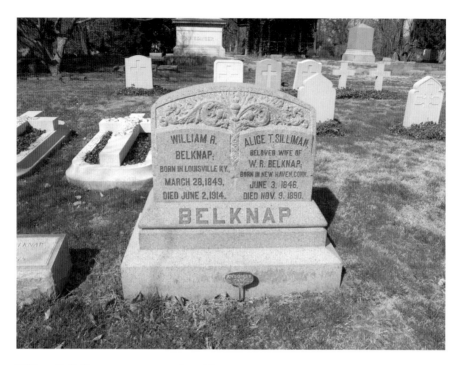

William R. Belknap monument at Cave Hill Cemetery, Louisville. *Courtesy of the author.*

to the YWCA. He was also involved in raising money for the building of the West Broadway Presbyterian Church and gave a $2,500 donation. The new church was erected on Thirty-Seventh Street and Broadway.[77]

In 1874, he married Alice Trumbull, a daughter of Professor Benjamin Stillman. She died, and he married Juliet Rathbone. They had four children: Mrs. Lewis Humphreys, Mrs. George Gray, Christine Belknap and William Belknap.[78]

The sudden death of his sister Lucy Belknap at her home on Second Street on March 28 was a great shock to him and was followed by a general breakdown. He was confined to his bed until April 21. He died on June 2, 1914, at his home on Longview on Upper River Road. He was buried in the Belknap plot at Cave Hill Cemetery, Section N, Lot 225-E½.

Morris Belknap was born on June 7, 1856. He received his early education in the private school of B.B. Huntoon and graduated in 1873. At the age of seventeen, he was sent with his brother William R. to travel Europe. After a year of travel, he returned to the United States and entered the Sheffield Scientific School at Yale, graduating in 1877. He took a postgraduate class in mechanical engineering, returned

Morris Belknap flower box–style grave at Cave Hill Cemetery, Louisville. *Courtesy of the author.*

to Louisville in 1879 and worked for his father at W.B. Belknap & Company; he later became a partner in Thomas Meikle & Sons, which manufactured plows and elevators. In 1883, he quit Meikle & Sons and joined his father's business, becoming vice-president of the company until his death. Known everywhere as an important factor in promoting the commercial interests of the city, he was for several years president of the Louisville Board of Trade. In 1895, he read a paper before the National Hardware Association at Pittsburgh, and in 1905, he was a delegate at the International Congress of Chambers of Commerce in Liège.[79]

In 1879, Morris joined the Louisville Legion as a private in Captain W.O. Harris Company. In 1890, he was elected captain of Company A for the First Regiment of the Kentucky Brigade, and three years later, he was promoted to lieutenant colonel. In 1887, he was honored to serve on the staff of General Simeon Buckner. In 1895, during the Spanish-American War, he was promoted to lieutenant colonel and then colonel of the First Kentucky and saw action in Ponce and Mayaguez in Puerto Rico. He retired from service in 1898 with the rank of lieutenant colonel.[80]

In 1903, he ran on the Republican ticket as governor but was defeated by Governor Beckham. He was chairman of the board of Louisville Park

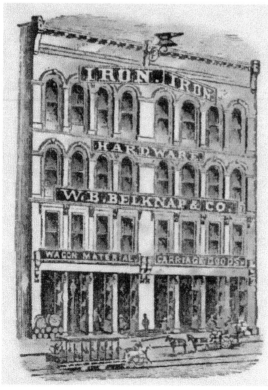

Above: Lucy Buckner Belknap flower box–style grave at Cave Hill Cemetery, Louisville. *Courtesy of the author.*

Left: Belknap Hardware. *From Elstner's* The Industries of Louisville, Kentucky and of New Albany, Indiana *(1887).*

Commissioners. He was also a member of the Pendennis Club, the Country Club and the Salmagundi Literary Society.

On July 14, 1883, he married Lily Buckner, the daughter of Simeon B. Buckner, who was a Confederate general during the Civil War and elected governor of Kentucky in 1887. She died in 1893. In her memory, Morris donated a bridge in Cherokee Park. They had four children: Gertrude and Lilly Belknap, Walter Belknap and Morris Belknap Jr. On July 16, 1900, Morris married Marion S.B. Dumont.[81]

He was never well after his service in Puerto Rico during the Spanish-American War. In January 1909, he was forced to his bed and did not leave his room until June 1. He traveled to New Hampshire, hoping that the fresh air would help in his recovery, but when he returned to Louisville in October, he immediately fell ill. On April 14, 1910, Morris Belknap died from pernicious anemia at this home on 1322 South Fourth Avenue. The funeral was held at his residence, and his body was taken to Cave Hill Cemetery and buried in Section N, Lot 225. Some of his pallbearers included Colonel Andrew Cowan, Judge Rudolph Blain, William Heyburn and Oscar Fenley.[82]

In 1960, Belknap Hardware became the largest hardware wholesaler in the world in sales, net worth and floor space, selling its products to customers in thirty states. On July 22, 1968, the company changed its name to Belknap Inc. David Jones, chairman and chief executive officer of Humana Inc., bought the company for $35 million in 1984 and hired Frank Lambert as president of Belknap Inc. On December 4, 1985, the company filed for bankruptcy and finally closed its doors on February 4, 1986.[83]

DENNIS LONG

Pipe Manufacturer

D ennis Long was born in Londonderry, Ireland, in 1816 and immigrated to the United States with his parents four years later. The first few years the family spent in America were in Erie, Pennsylvania, and later Pittsburgh.[84] While in Pittsburgh, Dennis Long experienced his first time with ironmaking. He became an apprentice and learned the trade as a molder. Around 1840, he moved to Louisville as a journeyman, but he saved up his money and became the owner of his own foundry. A machine shop was run in connection with the foundry, and he gained the reputation for his good and quick work. Long manufactured steam engines and large machinery at his shop, and the pipe he made was first used by the Gas Company of St. Louis.[85]

In 1860, he entered into a partnership with Bryan Roach, and the firm became known as Roach & Long. At the beginning of the Civil War, the company received a contract for the large Cornish pumping engine used in the Louisville waterworks. Roach was killed in an accident, and Long became the sole owner of the business. During the Civil War, he was a sympathizer for the Union government but did not fight in combat.

Although he produced steam engines and large machinery, the gas and water companies in Louisville and other cities persuaded Long to build cast-iron pipes. He built a large brick foundry with a slate roof on Ninth Street and the canal, with two casting pits, and produced about 15 tons of pipe every day. The new business was called the Louisville Pipe Foundry. He built an additional pit and began producing 25 tons of pipe daily. In October

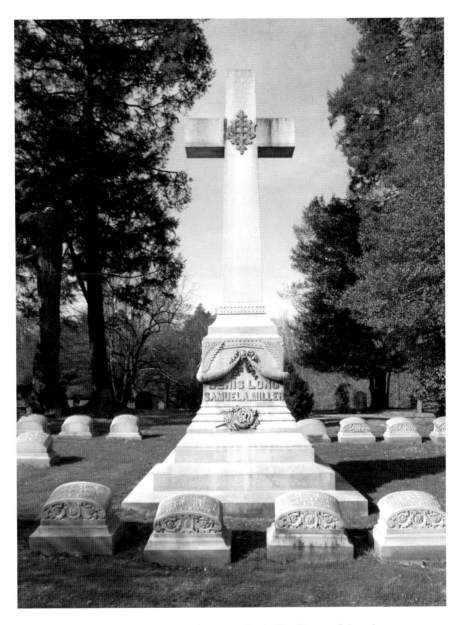

Dennis Long monument at Cave Hill Cemetery, Louisville. *Courtesy of the author.*

Dennis Long. *From Johnston's* Memorial History of Louisville from Its First Settlement to the Year 1896 *(1896).*

1868, he built an enormous factory on Fulton Street, between Jackson and Preston Streets, and called his new business the Union Pipe Works. The business had five casting pits and could produce 90 tons of pipe every day, with a yearly output of 27,000 tons of pipe. The range of pipe made was from two inches to six feet in diameter.[86] The factory eventually produced 250 tons of pipe daily. He employed more than five hundred men.

What made his factory possible was the abundance of coal and iron ore in the mountains of Kentucky. The raw product was brought in from the railroads. All the pipe was made in a charcoal furnace and not a stone coal furnace. Charcoal iron was superior to stone coal iron and produced a casting that was much stronger. His product was in high demand in eastern and foreign markets, and in 1870, his company brought in $1 million per year in revenue. He expanded his business and built a foundry in Columbus, Ohio, and another in Chicago. He supplied nearly all the large cities of the middle and some of the eastern states with pipe for water and gas mains.

Although Long was primarily involved in the pipe industry, he expanded his business interests and became president of the Jeffersonville Bridge Company, He used his wealth to prevent the total collapse of the Masonic Savings Bank. He also had interests in the Falls City Bank. Both of his banks failed.

On October 8, 1893, Dennis Long passed away. His body was laid out at his residence on 616 West Chestnut Street. The employees of his foundry, both white and black, assembled at the foundry and marched to the residence to visit his body. At 3:00 p.m., the funeral march began, and his hearse was followed by the employees. The employees marched into the church and were seated together rather than segregated. Some of Louisville's wealthiest and most prominent citizens attended his funeral, held at the Cathedral of the Assumption. Oddly, there was no music at his funeral, and no mass was held in the cathedral. His body was laid to rest at Cave Hill Cemetery, Section P, Lot 675.[87] Long was survived by his wife, Catherine Long, and

two of his children, Mrs. Samuel A. Miller and George Long. Another son, also named Dennis Long, had died in 1891. Long left a large estate valued at more than $1 million. He left no will but wrote that he wished to leave the entire management of his estate in the hands of his son George and his son-in-law, Samuel Miller. Long wanted his various businesses to continue without interruption.[88]

Benjamin F. Avery

Plows

Benjamin Franklin Avery was born in 1902 at Aurora, New York. His father, Daniel Avery, of Aurora, New York, had migrated to Groton, Connecticut. Daniel was one of the earliest settlers in Cayuga County and was a farmer and large landowner who represented his district for two terms in Congress. Benjamin was the sixth of fifteen children. He was accepted to Hamilton College but transferred to Union College and graduated in 1822. After studying law, to please his father, he was admitted to the New York City Bar. He hated the profession. He discovered that he had a natural mechanical inclination and decided to devote his life to improving and manufacturing plows.[89]

Benjamin managed to secure a small factory, and with $400 in his pocket, he took passage on a boat headed for Richmond, Virginia. He went to Clarksville, where he formed a partnership with Caleb H. Richmond and opened his first plow foundry in a pine log cabin. They began business with a single ton of metal, but by industry and frugality, they built up a prosperous business. They continued their business for a few years until the owners of the land refused to rent to them any longer.[90]

They moved to Milton, North Carolina, where they remained for a few years. Again, they were forced to move and traveled to Virginia, locating their business in Meadville. While there, Avery went into business with Schuyler Bradley, and a year later, they went to Rockbridge County. They remained in business for nine years, with Avery being the leading business manager.[91]

Left: Benjamin F. Avery. *From Allison's* The City of Louisville and a Glimpse of Kentucky *(1887).*

Below: Benjamin Avery headstone at Cave Hill Cemetery, Louisville. *Courtesy of the author.*

In 1842, Avery's father died, and he was appointed executor of the estate. The following year, he sold his business interests to a younger brother and retuned to Aurora. In 1844, Avery married Susanna Look, daughter of Samuel Look, a farmer from New York. They had six children: Samuel L., George, William, Mrs. Lydia Coonley, Helen Robinson and Gertrude Shanklin.[92]

In 1846, he commissioned a nephew, Daniel Humphrey Avery, to select the best place in the South or Southwest for a plow factory, and after looking carefully, David selected Louisville. In a few months, Daniel needed his uncle's experience and persuaded Benjamin to come visit the city. Benjamin arrived in Louisville on December 25, 1847, with the intention of only staying a few weeks, but he became interested in the business, saw the advantages that Louisville would afford and decided to make Louisville his permanent home. Benjamin Avery and his nephew, Daniel, set up a foundry at Main and Preston Streets. The business became very successful, supplying the South with farm equipment, including the Avery plow.

At the outset, Benjamin determined to produce not only the very best but also the cheapest plow, and he gave his personal attention to improving the clumsy tool. He made several alterations to the plow and invented a machine for bending wooden plow handles. He was the first to introduce the simple device by which a straight handle could be fitted to the back of the moldboard. Prior to the invention, the handle had to be bent at each end, but by casting with the moldboard, two small projecting pieces into which bolts could be inserted, the straight handle could be securely fastened. Any country blacksmith could put a new handle to a plow, and the handle did not have to bend to the shape of the moldboard.[93] Much of Avery's encouragement was given by people such as Cayuga County native James Hewitt, who lived in Louisville at Rock Hill and owned large plantations in the South. Hewitt told Avery, "My friend, if you can succeed in introducing your plow, you will have fortune enough, but I do not believe you can."[94]

In 1852, the factory was located at Fifteenth and Main Streets. When the Civil War broke out, Avery's operations were suspended when the Union army halted all shipments of the supplies being shipped to the Confederacy, and the foundry was used as a military hospital. After the Civil War, he started his business back and continued to make a profit.[95] In 1868, Benjamin formed a new firm, B.F. Avery and Sons, with his two sons, Samuel and George, and his brother-in-law, John C. Coonley. His new firm had the high reputation in connection with the adaptability and

superiority of the Avery plow for cotton, as well as general farming in the southern and southwestern states. The company also supplied a plow that worked well in a light garden, an ordinary plow for medium work, a special plow for the sugar lands of Louisiana and Cuba, another class for the sticky black land of Texas, the chilled plow for rocky fields and the riding or sulky plow for breaking up a prairie, as well as the huge and powerful railroad plow, for tearing to pieces a manufactured street. The cast or chilled plows were molded and ground. The steel plows, starting in slabs of steel, were sheared, pressed, welded, fitted into shape and then tempered and polished; millions of feet of selected white oak timber were cut, steamed, bent and finished into shape as plow beams and handles. All the iron and wooden parts of the plows were made at the factory.[96] By 1891, he had a capital stock of $1.5 million and employed six hundred men. The annual product exceeded 200,000 plows, including thousands of tons of blades and incidental plow parts. He made 143 different types of plows and cultivators, not including the different sizes of each kind.

His officers in the company were Samuel Avery, president and treasurer, and George C. Avery. The factory covered six acres of ground. Every part of the plow, from a bolt or nut up, was made and sold separately or in the completed plows. Undressed lumber, pig iron and plates of steel were brought into the factory. The business of using the raw materials was done in the factory. Avery and Sons used the best material, the best wood and the best iron and steel and employed the best mechanics. The cost of manufacture was reduced to the point that the factory could deliver plows and cultivating implements to any foreign country at prices that competed with goods made in the country, and it had a large foreign trade. There was no waste in the factory. A piece of wood that would not make two handles would make one handle and a round. The shavings and clippings were burned and helped the company save on coal. The machinery was always in use, and the money invested in the plant was not left to lie idle but rather returned a good percentage. Avery and Sons, together with other agricultural manufacturers, made Louisville the largest producer of plows in the world and the city's largest industry.[97]

Benjamin was known for his hospitality. He never refused to help a needy person. He had a large number of men in his employment, and some of them remained with the company for thirty years. He believed in treating them well. In 1875, he founded a monthly paper, the *Home and Farm*, which became a semi-monthly and had a huge circulation, making the paper an immense business.

On March 3, 1885, Benjamin Avery died at the age of eighty-four at his residence on Broadway and Fourth Avenue. He passed in the presence of his children and grandchildren. The funeral took place at the family residence. The burial was private and took place at Cave Hill Cemetery. He was buried in Section O, Lot 189. The pallbearers were selected from the oldest employees at the foundry. Honorary pallbearers included Andrew Cowan, J.B. Wilder and Dr. David Yandell.[98]

After his death, his sons continued to run the business. By the early 1900s, the company needed to expand, and it purchased land on Seventh Street at Mix Avenue. The new plant opened in 1910, and the business began to manufacture tractors. In 1915, a new tractor known as the Louisville Motor Plow was introduced to the public. The new plant expanded to fifty-eight acres and occupied eighteen buildings. George Avery died in 1911, and soon the company was no longer controlled by the family. By 1939, a new tractor had been designed called the Tru-Draft, and Avery made arrangements for the Cleveland Tractor Company to build the new tractor. The new tractor was called the General Model GG. By 1942, Avery and Sons had bought the equipment, inventory and all rights to the Cleveland Tractor Company, even though that company continued to build the tractor. In 1951, Avery and Sons merged its entire operations with Minneapolis-Moline Company, a large manufacturer of farm implements. The Moline company was eventually absorbed by the White Motor Company in 1969, then White into Allied Products in 1988 and then Allied into Allis-Gleaner Corporation. Tractors made under the B.F. Avery name had disappeared by the 1950s.[99]

JOHN COLGAN

Chewing Gum

J ohn Colgan was born on December 18, 1840. He was the son of William and Elizabeth Christopher Colgan. At the age of twelve, he became an orphan and was adopted by his uncle, Henry Christopher. His education came from the local public schools, and he attended St. Joseph's College in Somerset, Ohio. In 1858, he became an apprentice in a local drugstore, and in 1860, he established his own drugstore at Tenth and Walnut Streets (now Muhammed Ali Boulevard).[100] During the Civil War, his store was a popular spot for discussion and gossip about the war and for games of chess and checkers. At one point during the war, Colgan went to prison for a few months for making his strong pro-Confederate sentiment known to authorities. During his twenties, he was known as one of the best chemists in the South, and he liked to experiment with cough syrups. While making cough syrup, he had often taken the syrup of tolu, an extract from the balsam tree that came from Santiago de Tolu, Colombia. He came up with the idea of adding a powdered sugar and would roll the concoction into sticks. He gave them to the children of the neighborhood and the customers in his stores.[101]

The high cost of making the gum kept Colgan from making his product a serious business, but in 1879, a traveling salesman told him that a New Orleans house had on hand a large quantity of chicle. Chicle is a product of Mexico and Central America and is obtained from the milky juice secreted by the bark of the *Achros sapota*, the tree that bears the sapodilla. The salesman had imported the chicle to experiment with as a substitute of

John Colgan monument at Cave Hill Cemetery, Louisville. *Courtesy of the author.*

rubber. Colgan bargained for 100 pounds, but the salesman told him that he had to buy the whole shipment or none at all. Colgan ended up buying the entire 1,500-pound shipment. Realizing that chicle as a chewing substance was bland, Colgan added his syrup of balsam tolu to the chicle. He called his newest product Colgan's Taffy Tolu.[102]

He packaged the Taffy Tolu as small rectangles and fastened them with a rubber band. Later, Taffy Tolu was packaged in tiny, round tin boxes and called "violet chips" and "mint chips." Young folks sold the gum by the basket on the streets and on mule-drawn streetcars, using slogans such as "The Gum that's Round," "It Aids Digestion" and "Chew the Best."[103]

His Taffy Tolu took off, and soon Colgan's business became so great that in 1884 he took a partner in his drugstore, James McAfee. The firm was named Colgan & McAfee, and they opened a new drugstore at 938 West Walnut Street, where they sold their gum. After seven years, they sold their drugstore and devoted their entire business to making gum. John Colgan advertised his new gum in a limited way, but he did not advertise outside Louisville. One of his sons, William Colgan, wanted to tell the world about his father's Taffy Tolu. William decided to take his father's product to the

Taffy Tolu advertisement. *From Elstner's* The Industries of Louisville, Kentucky and of New Albany, Indiana *(1887)*.

World's Fair in Chicago in 1893. William had secured a contract with a large advertising firm that would have cost $10,000, but John Colgan told his son to come home. His son did not give up on advertising. Later, John Colgan established the Colgan Chewing Gum Company on Seventh Street between Market and Jefferson Streets. In 1906, William Colgan took over the company and built a factory and warehouse on Breckinridge Street between Seventh and Eighth Streets. This was the first bonded chicle warehouse in the United States. At that time, the chicle was refined and shipped from Honduras.[104]

William Colgan continued as the head of the corporation until 1911, when the Colgan Company was purchased in 1915 by the Autosales Gum and Chocolate Company of New York. Later, the company was bought out by Sterling Gum Company, which continued to manufacture Colgan chewing gums at Long Island City, New York. John Colgan retired when his corporation was sold.[105] He died from Bright's disease on February 2, 1916. His daughter, Bettie Colgan, and three sons, Henry C., J. Clifton and William, survived him. He also had a sister, Florence Esterle, who survived him. His funeral was held in his house on 1108 South Fourth Street, and the burial took place at Cave Hill Cemetery. He is buried in Section 12, 125.[106]

CHAPTER 13

HORATIO DALTON NEWCOMB
AND H. VICTOR NEWCOMB

Railroads and More

Horatio Dalton Newcomb was born on August 10, 1809, in Barnardstown, Franklin County, Massachusetts. His father, Dalton Newcomb, was a prominent and well-to-do farmer and was the eldest of a large family. Horatio did not like farming and became a schoolteacher and, later, a traveling agent, selling books for a schoolbook publisher. In 1831, at the age of twenty-two, he came to Louisville penniless and had no friends in the city. He started as a clerk in a small business dealing in furs and pelts but later entered the business of wholesale liquor. His business was located on Front Street, or what then was known as Commercial Row, near Fourth Street.

After accumulating a small amount of money from his business, he became associated with Ezra E. Webb in the commission business, dealing in flour and liquor. He began to build his fortune on the small foundation that he had accumulated, and in 1837, he was a thriving merchant in the wholesale liquor business. A few years later, his brother Warren Newcomb came to Louisville and became a partner with H.D., with the name of H.D. Newcomb & Bro. The brothers' firm dealt in wholesale groceries—specializing in molasses, sugar and coffee—and became one of the largest in the West. About ten years later, after coming to Louisville, Horatio married a daughter of Thomas W. Read, and his first house was located opposite the Galt House, which two years later was crushed to the ground when the large liquor house of S.T. Suit, which was under construction, suddenly collapsed and fell over onto Horatio's house.[107]

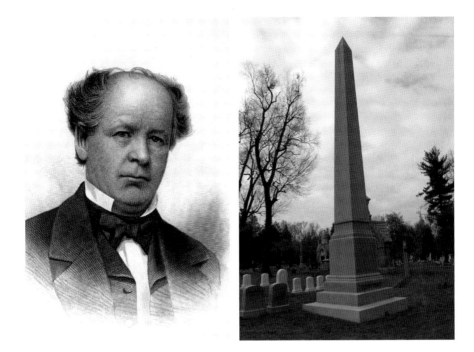

Left: Horatio Dalton Newcomb. *From Johnston's* Memorial History of Louisville from Its First Settlement to the Year 1896 *(1896).*

Right: Newcomb obelisk monument at Cave Hill Cemetery, Louisville. *Courtesy of the author.*

In 1850, the building of a cotton mill at Cannelton, Indiana, had been planned by Hamilton Smith, James Ford and others, but after several disastrous mishaps, the business was on the brink of bankruptcy when Horatio stepped in with a large payment, ensuring that the business was financially secure. From the day the mill started, Newcomb had a controlling interest in the business, and although he was one of the largest and most successful commission merchants in the West, the bulk of his great estate was made in the cotton mill.[108]

In 1856, Horatio made his second-largest investment. He went into a partnership with his brother Dwight Newcomb, who came to Kentucky soon after the arrival of Horatio. The two brothers leased the Cannelton coal mines, which they operated successfully for several years until Horatio withdrew, leaving the business in the control of Dwight.[109]

By 1859, Horatio was one of the wealthiest men in Louisville. He built a mansion, designed by Henry Whitestone, on Broadway near Second Street. In 1865, the Galt House was burned in a huge fire. Horatio took an interest

Horatio D. Newcomb headstone
at Cave Hill Cemetery, Louisville.
Courtesy of the author.

in the hotel and helped to rebuild the famous landmark. He was president of the Western Financial Corporation, and in 1862, during the Civil War, he was one of the first inaugurators of the pro-Union Louisville Board of Trade and became the board's first president and head. He was a constant contributor of his talent, energy and means to support and was a leading actor in all public enterprises in the city.[110] He continued to conduct his business on Fourth Street until 1869, when he was succeeded by his oldest son, Victor Newcomb, becoming the senior partner in Newcomb, Buchanan & Company. When the business changed hands, Victor converted the firm from grocery to wholesale liquor, which became the largest manufacturing business in the state. Newcomb, Buchanan, & Company also owned the Anderson and Nelson Distillery Companies, which made Kentucky bourbon, rye and malt whiskies and was considered at the time one of the most valuable properties of the kind in the state of Kentucky. They also owned the Louisville Public Warehouse, which offered accommodations for tobacco dealers, distillers, wholesale liquor dealers, importers of foreign goods, shippers and dealers of every description of merchandise requiring cheap, careful and responsible storage. The warehouse was a seven-story-tall brick warehouse.

While running his different businesses, Horatio took an interest in the Louisville & Nashville Railroad, and from the early history of the railroad, he became one of its strongest and most influential leaders. He took a large stock in the railroad and worked hard for the business's success by personally going from door to door among the citizens of Louisville asking for their subscriptions, exerting his powerful influence on the railroad's behalf. He also was lending the company his individual means and endorsements to sustain and build up the railroad's credit. For sixteen years, Horatio was one of the directors of the railroad, and when James Guthrie, the founder of the Louisville & Nashville Railroad and president, died in 1869, Horatio was elected the railroad's president.[111]

Horatio had placed his entire fortune in jeopardy, but by lending his endorsements and placing all his collateral at the railroad's disposal, the railroad was saved from bankruptcy. In his transactions with parties in London, he had made friends with some of the most prominent and wealthy bankers in England, and through his influence with such capitalists as Baring & Brothers of London, negotiations were made for the loans that relieved the Nashville railroad from collapse.[112]

The strains of saving the railroad began to take a toll on his health, and when he traveled to London, England, with his son Victor Newcomb to negotiate a loan, he suffered a stroke from which he never recovered. He died on August 18, 1874, surrounded by his family and some of his friends. He was married to Mary "Nina" Smith, the eldest daughter of John Smith. He had two children. When he died, he was one of the wealthiest citizens of Louisville. His estate was valued at more than $1 million, and some speculated that he had more than $2 million. When the Louisville & Nashville Railroad learned of the death of Horatio Newcomb, it decreed that the depot buildings and all the engines were to be draped in black for thirty days. He was buried at Cave Hill Cemetery, Section P, Lot F, Grave 4.[113]

On June 23, 1838, Horatio had married his first wife, Cornelia Read, the daughter of Thomas Read, and they had four children, but his wife showed signs of insanity and was placed in the care of a nurse. In 1852, his wife grew worse. In a psychotic rage, she took four of their children to the attic of their home on Main Street between Brook and First Streets and threw them out of the window to the pavement below. Ernest, age five, was killed instantly, and the smallest girl also died. Two of the children survived, H. Victor Newcomb and Herman Newcomb. The wife stated that God had called for the children and she was sending them to him. She was placed in the Massachusetts General Hospital for the Insane. Her father, Thomas Read, had also gone insane and was housed in the Lexington Insane Asylum.

In April 1871, Newcomb obtained a divorce from his wife, Cornelia Newcomb, on the grounds of her insanity. The divorce was granted on June 23, 1871, and a short time later, Horatio married Mary "Nina" Smith, the daughter of John B. Smith, who was an officer of the Western Financial Corporation. After they were married, they spent a year abroad, and they had two children. After their trip abroad, they returned to their home on Broadway. A year later, he was dead, leaving a huge estate and property to be settled between his wife and H. Victor Newcomb. In his will, he bequeathed $2,500 per year to support his first wife, Cornelia, who was a patient at the

insane asylum for the rest of her life. He gave his sister Mary an income of $1,500 per year. He gave his sister Ellenor Burnett $600 per year for life. He gave his brother Wesson $2,000 per year for life. He gave his brother Almon $1,000 per year for life. He gave the two children of Ellenor Burnett $2,000 each for life. He gave the Episcopal Orphan Asylum $10,000. He gave the executors money to pay for a library. He willed $10,000 for the library up front, with an additional $75,000 within three years of his death. He gave John Smith and Thomas Barrett $200,000 to form a trust to be used for his wife, Mary Newcomb, and her children. In his will, he stipulated that if his wife had no children one year after his death, the house on Broadway, between First and Second Streets, would be sold at auction by his son Victor Newcomb. He gave Victor $400,000.[114]

On March 28, 1875, a lawsuit was filed in the Louisville Chancery Court in the name of his first wife, Cornelia, that the marriage to his second wife, Mary, was illegal. On April 6, 1875, the courts agreed that the second marriage was illegal and that the divorce was void. The courts stated that the executors of the will must pay Cornelia Newcomb, the "former wife" of Horatio, the sum of $2,500 per year for life.[115]

On December 2, 1877, Horatio D. Newcomb's house, including all the furnishings, was put up for auction. John Watts Kearney had bought the house when he offered Victor Newcomb $44,000. A marble bust of James Guthrie sold for $55, and a piece of statuary made by the famous Kentucky artist Joel Hart was also sold.[116]

On March 26, 1908, another lawsuit was filed in the Court of Appeals. The court held that H.D. Newcomb's will was upheld, that Victor Newcomb was not entitled to any part of the trust fund of $200,000 and that the money should go to H. Dalton Newcomb.[117] Tragedy continued to plague the Newcomb family when Herman Newcomb, the brother of Victor Newcomb, died at the age of twenty-five from an opium overdose.

H. Victor Newcomb, the son of Horatio Dalton Newcomb, was born on July 26, 1844, in Louisville. He studied in the local schools under the distinguished educator B.B. Huntoon, who was the head of the Kentucky School for the Blind. He entered a boarding school on Long Island, New York, and later entered Harvard, but ill health caused him to leave the college. While in New York, H. Victor Newcomb engaged in the coffee business with his uncle. He completed his education in England and traveled throughout southern Europe and the European continent. At one point during his travels, he went to Africa, crossing the Sahara Desert with a caravan of Arabs. After his return to America, when he was seventeen, he

Horatio Victor Newcomb. *From Johnston's* Memorial History of Louisville from Its First Settlement to the Year 1896 *(1896).*

traveled to the western plains of the United States. After his travels in Europe and in America, he settled in Louisville and married Florence Danforth in 1866. In 1865, he took an interest in the banking house of E.D. Morgan & Company of New York. A few months later, he became a partner in the firm of Warren, Newcomb & Company of Louisville, and the company name was later changed to H.D. Newcomb & Company and later still to Newcomb, Buchanan & Company. This firm was in the grocery and wholesale liquor business and also owned the Cannelton Cotton Mills. In 1874, while his father was president of the Louisville & Nashville Railroad, Victor was sent to London in the interest of the railroad and successfully floated a large bond issue for the railroad while there. For his success in selling the bonds in England, Victor was made a director of the railroad.

Following the death of his father, Victor was elected to succeed his father as director of the L&N. Later, he was elected vice-president of the railroad, and in 1880, he was elected president of the Louisville & Nashville. He was only thirty years old when he became president and was known as the "Boy President." Soon after, he showed his abilities by organizing a belt line system that connected the terminals of thirteen railroads. He ran the railroad for a year. In 1881, he was forced to resign as president of the Louisville & Nashville due to ill health.[118]

After his health improved, he moved to New York. By this time, he was reputed to be worth $10 million. He was a large operator on the stock market and became a magnate of Wall Street. He was elected president of the United States National Bank and served the bank for fourteen months but resigned, again due to ill health. For the next twenty years, he traveled or stayed at his residences in New York and Atlantic City.

By 1891, Victor's mind had became clouded, and he was temporarily confined to a mental hospital. He recovered and resumed his operations on Wall Street, but the attorneys for his wife and a committee hired by the courts declared that Newcomb's recovery was fictitious, that his old skills

Horatio Victor Newcomb headstone at Cave Hill Cemetery, Louisville. *Courtesy of the author.*

never came back and that he lost the great bulk of his vast fortune in wild speculation. The courts put his house on Fifth Avenue and the villa at Elberon in the hands of General Wager Swayne and James A. Howes, who were appointed by the court as trustees for the estate of Victor Newcomb.

On November 16, 1900, Victor Newcomb made a desperate fight in court to regain possession of what remained of his fortune. The commission appointed by the courts still had control of his possessions on the grounds that he was a lunatic and incapable of managing his own affairs. His wife and son, Herman Newcomb, stated that for twenty years Victor had periods of mental instability due to the use of the drug chloral—while on the drug, he would go into wild speculation until his estate had dwindled from millions to only $500,000. They stated that Victor would hallucinate that his son and wife conspired to kill him and take his fortune. The amount of money at stake was $275,000.[119]

By 1908, Victor had moved to a cottage on 172 States Avenue in Atlantic City, New Jersey. He died on November 4, 1911, from "neuralgia of the heart." He was survived by his wife, Florence; his daughter, Edyth Ward Newcomb; and his son, Herman Newcomb. He had another daughter, also named Florence, who died as a child.[120] He was buried at Cave Hill Cemetery, in the family plot, Section P, Lot F, Grave 12.

ANDREW GRAHAM

Tobacco

Andrew Graham was born on August 17, 1813, in County Tyrone, Ireland. Andrew Graham's father was Scotch-Irish and was a descendent of the Scotch Graham of the House of Montrose. His father had a fortune in his early life, and his estate was noted for its picturesque beauty. During his childhood, Andrew Graham received a good education, but in 1830, his entire family moved to Quebec, Canada. Later, the family moved to Indiana and built a new home. Unfortunately, his father drowned while crossing the White River, and Andrew Graham along with his mother and siblings were deprived of their fortune by unprincipled land agents, who took advantage of the grieving family and the unsettled estate of his father's business affairs. Graham had visited Louisville several times and decided to move to Kentucky. Graham's father had friends who had already settled in Louisville and would help with Graham's relocation. Luckily, he had $175 to help him find a job.[121]

He rented a storeroom on Main Street between Seventh and Eighth Streets and started a small grocery. His business prospered, and he became the owner of his own building. In a few years, he was numbered among the wealthiest merchants in the city. He tore down his old building and built up a block in the same location, and not too long after, he bought an adjoining lot and constructed another building with two stores in operation. He was only twenty-three years old and became known as the "Boy Merchant." After thirteen years in the grocery business, his health began to decline, and he sold his business, which was worth about $40,000 to $50,000.

Andrew Graham's Classical Revival–style monument made by the Muldoon Monument Company at Cave Hill Cemetery, Louisville, Kentucky. *Courtesy of the author.*

Within a few months, he had recuperated his health to the point that he entered the pork business and did very well, but by the end of the year, he decided to put all his money into the tobacco trade. It was not long before he became known as a prominent buyer.

In 1864, he bought ten thousand hogsheads of tobacco. When he arrived in the city in 1831, only about five hundred hogsheads were handled yearly in the city. During the next twenty years, the trade increased to twelve thousand hogsheads of tobacco per year. Andrew Graham was instrumental in raising stock to build the Pickett Warehouse, on the corner of Eighth and Main Streets. One year from the completion of the building, the operation increased to twenty-four thousand hogsheads of tobacco. Graham became known as the founder of the tobacco trade and held the world record of having purchased the largest number of hogsheads of tobacco in a single year by any individual, and he was never beaten in this record.

For many years, Andrew Graham was a member of the Board of Trade, a director of the Tobacco Board of Trade, a member of the New York Board of Trade and a trustee of the Louisville Female College. He was also a director of the House of Refuge and the founder of the Industrial School of Reform. He worked tirelessly to make the school a reformative institution rather than a correctional one, avoiding sectarianism in the school's management and bringing to their support the combined church influences of the city.

On January 23, 1838, Andrew Graham married Miss Martha Parker, daughter of Samuel Parker Sr. of Louisville, who was one of the pioneer citizens of the city. Martha Parker was born on August 4, 1818, and was a great-granddaughter of General Lord William Howe, who was the commander-in-chief of the British forces during the American Revolution. She was one of twelve sisters. Andrew and Martha had three children: Andrew Graham Jr., who unfortunately died in 1862, and two daughters, Emily C., wife of J.T.S. Brown, and Mattie E. Graham. Their home was located on Fourth Avenue. They had notable engagements at their home and hosted members of the British nobility. Their home welcomed members of all churches, and public men and business acquaintances were made to feel at home in his company. Graham's New Year's receptions were notable occasions, famous for the cordial welcome extended to his guests.

On November 15, 1884, Andrew Graham died near Brandenburg, Kentucky. He moved to the city a number of years before, where he wanted to enjoy his remaining years in rural enjoyment. His body was taken to Louisville. His funeral was held at Warren Memorial Church. A large number of relatives, friends and acquaintances attended the funeral. A

long procession of carriages followed the body to the family vault at Cave Hill Cemetery, Section G, Lot 79. After his death, Mrs. Graham moved to Cloverport to live with her daughter.[122]

On January 12, 1894, Andrew Graham's widow, Martha Parker Graham, passed away. She was one of the leading society women of Louisville. She died at the home of Judge John Allen Murray in Cloverport. She was the mother of Emily Graham, who married J.T.S. Brown, and Mattie Graham, who married Judge John Allen Murray of Cloverport. She died of a stroke. Her funeral service was held in Cloverport, but her remains were brought to Louisville for another funeral service at Mrs. Brown's home. Martha was one of the oldest members of the Warren Memorial Church. Her pallbearers included Mr. J.T.S. Brown and Judge J.A. Murray, as well as her grandchildren, Graham Davis, Creele Hewett, J.T.S. Brown Jr. and John Allen Murray Jr. The burial was held at Cave Hill Cemetery, Section B, Lot 80.[123]

THOMAS JEFFERSON SR.

Wholesale Grocer

Thomas L. Jefferson was born in Baltimore, Maryland, on February 15, 1826. He was the oldest son of Thomas and Elizabeth Smallsread Jefferson. His father was a blacksmith, and his grandfather was a sailor. His mother was a businesswoman who ran a grocery store. In 1831, the family moved to Louisville. The shop that his mother ran was so successful that the father had to give up the blacksmith shop in order to help out with the grocery. Thomas was given a good education by Noble Butler and J.H. Harney, but at the age of sixteen, he had to leave school in order to help out with the grocery store.[124]

In 1842, young Thomas worked as a clerk in his mother's store. In 1852, when he was twenty-six years old, Thomas went into a partnership with Charles Gallagher in the wholesale and retail grocery business. The partnership dissolved a year later, and Thomas went into business for himself, opening a wholesale and retail grocery store on Market Street, below First Street. The business was so successful that he built a spacious home on the southeast corner of Market and First Streets.

He was also the sole agent for the Kanawha salt manufactories. By this time, his wholesale business had grown to the point that he had to open a branch house on Main Street. He employed his two brothers and A.W. Jennison, under the firm of T.L. Jefferson and Brothers. The firm dealt with mostly in salt and flour and traded with the South and Southwest, becoming one of the best-known commercial establishments in Louisville. On May 28, 1848, Thomas married Elizabeth Ann Creagh. They had nine children, four daughters and five sons.

Left: Thomas Jefferson obelisk monument at Cave Hill Cemetery, Louisville. *Courtesy of the author.*

Below: Close-up of Thomas Jefferson monument, Louisville. *Courtesy of the author.*

In 1875, Thomas was appointed executor of John Bull's estate. Dr. John Bull was a manufacturer of proprietary medicines. Dr. Bull had left a large estate and a great business. In his will, Dr. Bull stipulated that Jefferson should take charge of his estate and his business as executor and trustee. The interests of John Bull's business took up so much of Jefferson's time that he had to move from his Main Street home, making room for his eldest son, Thomas Jefferson Jr., and John W. Day. In 1879, after two years of running the estate and business, Jefferson resigned from his position as executor of John Bull's estate because of a difference of opinion having arisen from the construction of the will and litigations that arose from Dr. John Bull's will.

In 1851, Thomas was elected to fill a vacancy on the Board of Council. He was reelected for three executive terms, and in 1860, he was elected to the Board of Aldermen. In 1867, he was elected to the lower house of the Kentucky state legislature and was then reelected. When his second term was over, he was elected to the state Senate for one term. He was a member of the Democratic City Executive Committee and also a member of the State Central Committee for several years. In 1869, he was a delegate to the Democratic National Convention in New York.

He was also the trustee for the United States Marine Hospital, the Alms House, the Work Home and the Pest House. He served from 1870 until his death on the directory of the House of Refuge. For a number of years, he was Trustee of the Louisville Female School. In 1874, he was appointed as Governor Leslie's Trustee for the Kentucky Institute for the Blind. He was reappointed by Governor McCreary and Governor Blackburn. He was also trustee of the American Printing House for the Blind.

Thomas was one of the incorporators of the Masonic Widows and Orphans Home. In 1867, he was elected director and president of the board for the Home. In 1861, Thomas took all the degrees of the Symbolic Masonry and afterward of Capitulars and Chivalric. In 1882, he was elected Master of the Excelsior Lodge No. 258, Free and Accepted Masons; of King Solomon Royal Arch Chapter No. 18; and of DeMolay Commandery, No. 12, Knights Templar, being elected treasurer in 1873. He was also a member of the Sons of Temperance and was presiding officer of his division.

In 1854, he was a member of the Board of Managers of the Methodist Episcopal Church South. He was secretary of the Louisville City Missionary Society of the Church. He was superintendent of the Bethel Sunday School for fifteen years, which he organized and assisted in organizing Sebon

Masonic Home for Widows and Orphans. *From Allison's* The City of Louisville and a Glimpse of Kentucky *(1887).*

Chapel, ME Church South. He was a member of its board and recording steward and superintendent of the Sunday school.

He was a member, director and vice-president of the Board of Trade. In 1859, he served as a director of the Bank of Louisville. From 1872 to 1874, he was a director of the Louisville & Frankfort and Lexington & Frankfort Railroad companies. In 1879, he was elected director of the Kentucky and Louisville Mutual Insurance Company, and in July 1880, he was made the company's president.

In 1866, he was linked with the Southwestern Relief Commission, which was created to help provide food and clothes for those who had been left destitute by the ravages of the Civil War in many portions of the South. He was chairman of a committee to receive and disburse funds raised by the Masons of Kentucky for the relief of the Chicago fire suffers in 1871.

He died from cancer of the stomach at his home on Gray Street, near Floyd, at 2:30 a.m. on March 23, 1884. His funeral took place at the Broadway Methodist Church. The church was packed to overflowing. The front pews were reserved for the relatives and members of the Masonic fraternity. About 130 boys and girls from the Masonic Widows and Orphans Home occupied seats on the elevated platform in front of the altar, and as many from the House of Refuge, including the Little Commandery, were arranged in pews to the left of the western side.

The coffin was followed by the members of the Masonic fraternity up the right side of the aisle and by the Knights of the Templar up the left. The Knights were in full uniform, while the Masons were wearing the sprig of evergreen and white apron that made up the funeral regalia of the mystic brotherhood. The Sir Knights were seated after prayer in the middle pews on the left. A group of the Masons was placed in the pews to the right of the main aisle and the others marched to the other side of the church.[125]

The choir sang "One Sweetly Solomon Thought." Next was sung Thomas Jefferson's favorite hymn, "There Is a Fountain Filled with Blood." After the funeral, the coffin was taken to Cave Hill Cemetery and laid to rest in Section O, Lot 67. One hundred carriages followed the coffin to Cave Hill. The services took so long that the sun had gone down and lamps were lit in the carriages. The floral arrangements were so large and numerous that every portion of the grave was covered. Two of the larger arrangements were beautiful pillars surmounted with a dove, sent from the House of Refuge. Another design was an elegant "Gates Ajar" from several bankers of Louisville, and a third was an exquisite star design from the members of the Excelsior Lodge. His pallbearers were from the DeMolay Commandery and the Excelsior Lodge. His honorary pallbearers were the leading businessmen of Louisville, including James B. Wilder, James Bridgeford, Dr. T.S. Bell, Hamilton Pope, Thomas Barrett and J.H. Lindenberger.[126]

PAUL JONES JR.

Bourbon

Paul Jones Jr. was born in Lynchburg, Virginia, on September 6, 1840. During the Civil War, Paul Jones Sr. and his two sons, Paul Jones Jr. and Warner Jones, supported the Confederacy. Both brothers enlisted in the Confederate army. Warner became a colonel and fought in the Battle of Perryville, Kentucky, on October 8, 1862. He died during the Siege of Atlanta in 1864. After the Civil War, Paul Jones Sr., along with his living son, Paul Jones Jr., moved to Atlanta, where they both became successful in the whiskey business. Paul Jones Sr. died in 1877.

In 1883, a strong temperance movement brought prohibition to Georgia, so Paul Jones Jr. moved to Tennessee, where he continued to expand the whiskey business as a broker for various distillers. In 1884, Paul Jones decided to move to Louisville, Kentucky. In 1888, Jones bought assets from whiskey maker R.M. Rose, who claimed to name his bourbon after Jones's daughters. In another version of the story, the name Four Roses was based on Rose, his brother and their two sons. Jones acquired the Four Roses name and along with other Roses assets operated their company under the name Paul Jones Company, which was located on 138 Main Street on Whiskey Row.

Jones became president of the J.G. Mattingly Distillery at Thirty-Ninth and High Streets. He was also director and vice-president of the American National Bank and president of the Louisville Fair and Driving Association.

In 1892, Paul Jones registered the Four Roses trademark, and his name and brand became known throughout the country. He believed in advertising,

Paul Jones Jr. Mausoleum at Cave Hill Cemetery, Louisville. *Courtesy of the author.*

and in New York he rented space on a building at Madison Square for a sign of incandescent electric lights at a cost of $1,200.[127]

Paul Jones Jr. never married and made his residence for a number of years at the Galt House. He died on February 23, 1895, in Louisville from "abscesses of the brain." He was surrounded at his deathbed by his three nephews, Lawrence, Sanders and Bland Ballard Jones. When he died, he was known as one of the wealthiest and most widely known distillers in Kentucky.[128]

His funeral was held at the Cavalry Church. The flower arrangements were profuse, and many were handsome in design. Among them were a large shaft of wheat, signifying that he lived to seventy years of age, and a broken wagon wheel. His remains were taken to Cave Hill Cemetery, where they were temporarily placed in a public vault until a mausoleum could be built by his family. The casket was one of the most expensive and handsome caskets seen in the city at that time, made of solid red cedar covered with imported broadcloth. The handles were oxidized silver, and the knobs were made of solid gold. His mausoleum vault is of a Greek Revival style, and

inside is contained a beautiful stained-glass window. He is buried in the mausoleum vault, Section 5, Lot 1.[129]

The Jones family continued to run the family business. Jones relatives bought thousands of barrels of bourbon and brokered them. Prohibition changed the focus of the company, whereupon it began to make medicinal whiskey. After Prohibition, Paul Jones Company bought the Frankfort Distilleries, where the company bottled Paul Jones and Old Prentice until World War II. In 1943, Canadian distiller Joseph Seagram & Sons Inc. purchased the Frankfort Distilleries and Paul Jones and Company and other distilleries, including Old Hunter, Lewis Distillery, Athertonville Distillery, Henry McKenna Distillery and Old Prentice Distillery. Seagram moved the Four Roses brand to Europe and Asia. In 2002, the Kirin Brewery Company bought the Four Roses brand trademark and production facilities. The new company was named Four Roses Distillery LLC, and Four Roses was once again sold in the United States.[130]

DR. NORVIN GREEN

The Telegraph

J ust before the Civil War broke out on the American landscape, there were many new innovations in technology that would be a play a key role in Kentucky and the country during the Civil War. Railroads, the rifled musket and the transcontinental telegraph were all used by both Union and Confederate forces during the Civil War. Norvin Green would play a role in the Western Theater during the Civil War, and later after the war, he would become the president of Western Union.

In 1844, Samuel Morse, the inventor of the telegraph, sent the first message over the thirty-seven-mile telegraph line he had stretched between Washington, D.C., and Baltimore, Maryland. Fifty different companies owned and operated the network of telegraph wires, so messages had to be transferred between companies and then forwarded to their eventual destinations. On October 24, 1861, the transcontinental telegraph reached Sacramento, California, connecting East Coast and West. Norvin Green changed all that.[131]

Norvin Green was born in New Albany, Indiana, on April 17, 1818. When he was a child, his parents moved to Louisville, Kentucky. His father, Joseph, was a farmer and a veteran of the War of 1812. Green was educated in the local schools. At the age of sixteen, he bought a flatboat and determined to try his luck running a floating grocery store down the Mississippi. His primary customers were lumberjacks. The trip was a success, and he received a good number of orders that had to be sent by steamboat. His credit was good, and all of his orders were honored. The lumberjacks wanted iron

Norvin Green's monument at Cave Hill Cemetery, Louisville. *Courtesy of the author.*

boots, and Green made a profit selling the boots. Green also ran a successful business chopping and selling firewood.

The money he earned from his businesses allowed him to pay for a medical education. He studied under a local doctor and eventually resumed his studies at the University of Louisville. In 1840, he graduated from the university with his medical degree and started a successful practice. He later became physician of the Western Military Academy in Drennan Springs, Kentucky. He soon turned his attention to politics and was elected for several terms to the Kentucky legislature, and in 1853, he was appointed commissioner of the United States in charge of the construction of the customs house and post office in Louisville.

While engaged in his duties as commissioner, he became one of the lessees of the United New Orleans and Ohio, also known as the Morse line, and "The People's" telegraph line between Louisville and New Orleans. After he became president, he united the company under the name Southern Telegraph Company. Both lines started from Louisville and passed through Nashville into Middle Tennessee, where they divided. The Morse line went to Somervile, Tennessee, with a branch to Memphis, Juanita and Potontoc to Greenville, Mississippi, and from there the lines went down the Walnut Ridge to Vicksburg, Grand Gulf and Natchez to Baton Rouge, Louisiana. The People's line went from Lawrenceburg to Tuscumbia, Alabama, then to Columbus, Canton, Jackson, Gallatin and Liberty, Mississippi, to Baton Rouge and finally to New Orleans. One only needs to look at the names and realize how important these cities would become during the Civil War. After Green consolidated the company into the Southern Telegraph Company, he forever became identified with the history of the telegraph.[132]

The telegraph helped transform warfare. Both the Union and Confederate armies used the invention. Telegraph wires enabled field commanders to

remain in constant touch with their bases, to learn quickly of changing developments and to rectify shortages of men and materials as they occurred. Telegraphs enabled commander of armies divided by thousands of miles to coordinate their activities. For the first time, government leaders had direct contact with their commanders in the field. Both Union president Abraham Lincoln and Confederate president Jefferson Davis corresponded with their commanders, almost on a daily basis. Reporters from newspapers and magazines kept the public informed about action in the field. The *New York Times* had a Louisville correspondent who used the telegraph wires to keep the eastern coast informed about the war in the Western Theater.[133]

Telegraph wires generally ran alongside railroads. The system was privately owned and operated by civilians, and the work of operators was highly prized by both sides. The Union considered telegraphers vital to the functioning of the army, and they were exempted from the draft. Civilian operators played an important role in the operation of field armies, striking their tents and putting their wagons into line when armies moved. In laying and maintaining wires at army and corps headquarters, they faced many of the hazards of combat. Operators suffered causalities of nearly 10 percent, about the same as combat troops. Civilians strung about 15,000 miles of wire and transmitted and received an estimated three thousand messages per day during the war. By 1864, the Union Military Telegraph Service was using more than 6,500 miles of wire, with 76 miles of underwater cable.[134]

Telegraph lines also were used to eavesdrop on and mislead enemies. Confederate general John Hunt Morgan took soldier-telegrapher George "Lightning" Ellsworth on raids into Kentucky. Ellsworth learned the tapping habits of other telegraphers and skillfully tapped into Green's telegraph lines to intercept orders sending Union cavalry and infantry in pursuit of Morgan and to send misleading information on the location of Morgan's raiders. Ellsworth even sent messages between Morgan and Chief Editor George Prentice of the *Louisville Journal*.

By 1866, the Southern Telegraph Company and the American Telegraph Company had been consolidated into the Western Union Telegraph Company. Dr. Green was chosen vice-president. Western Union owned seventy-five thousand miles of telegraph line and had eliminated all of its competition. With the exception of about three years, during which Green accepted the presidency of the Louisville, Cincinnati and Lexington Railway Company, he retained the office until January 1873, when he returned to duty as vice-president of Western Union. In 1878, Green became president of Western Union and took control of

the company. He was also a member of the Telegraphic Mutual Benefit Association and helped to improve the telegraphic service. He was also founder of the American Institute of Electrical Engineers, and from 1884 to 1885, he was the organization's first president. He died on February 12, 1893, in his house in Louisville, Kentucky. He amassed a fortune of more than $2 million in stock and real estate. Green was laid to rest at Cave Hill Cemetery, Section B, Lot 77.[135]

Norvin Green was a successful doctor and politician, and his contribution to communication with the expansion of the telegraph had an immense impact on the Civil War. Before 1861, troops could only communicate with their field commanders by signal corps or runners on foot or horseback. With the telegraph, field commanders could stay in touch with their superiors in Washington or Richmond. Reporters could quickly dispatch news from the battlefield to their newspapers and magazines. By the time of the Civil War, the telegraph had brought the nation together from the East Coast to the West Coast. With the Southern Telegraph Company in Louisville, field commanders could telegraph vital information from the field to their commanders in Louisville and from there relay the information to Washington. The Southern Telegraph Company had an integral role in the war in the Western Theater, and the Union army had Norvin Green to thank.

CHAPTER 18

MAJOR JOHN HESS LEATHERS

Jean Cloth

On April 27, 1841, John Leathers was born in Middleway, Jefferson County, Virginia, now West Virginia. He was the son of cabinetmaker William and Elizabeth Hess Leathers and was the youngest of seven children. He was educated in the local public schools and Martinsburg. While working for his father, he learned the skills of writing bills of sale, delivering invoices and keeping inventory, which would serve him well later in his life. By age sixteen, Leathers was working at a dry goods store in Martinsburg, Virginia.[136]

In 1859, Leathers moved from Virginia to Louisville, Kentucky, to work for his uncle, George Cary, who was a local retail druggist. One year later, he became a bookkeeper in the wholesale clothing firm of William Terry & Company. The store was located on the corner of Sixth and Main Streets. When the Civil War broke out across the country, Leathers decided to return home to Virginia and joined the Second Virginia Infantry, Stonewall Jackson's brigade, of Confederate general Robert E. Lee's Army of Northern Virginia. At the Battle of Gettysburg, Leathers received a severe wound. He decided that his fighting career in the Civil War was over, and when he was well enough to travel, he returned to Louisville. In 1865, he joined the firm of Jones & Tapp, a wholesale clothing broker, as a bookkeeper. In 1870, he became a partner and renamed the company Tapp, Leathers and Company.

Throughout the 1870s and 1880s, Leathers managed the operations of Tapp, Leathers and Company. By 1885, he had five hundred employees and

Right: John Leathers. *From Steve Munson's* The Civil War Battles of the Western Theater.

Below: John Leathers's headstone at Cave Hill Cemetery, Louisville. *Courtesy of the author.*

manufactured Kentucky jeans and lines of men's and boy's dress clothing for retailers throughout the country. On April 1, 1885, Theodore Harris moved his Louisville Banking Company to Fifth and Market. Harris hired Leathers to oversee the day-to-day operations of the Louisville Banking Company. Within three years, Leathers had tripled the deposits of the Louisville Banking Company, which became Kentucky's largest financial institution, and in 1895, he became president of the Kentucky Bankers Association. He was also president of the National Building and Loan Association, vice-president of the National Surety Company of Missouri and director of the Louisville Insurance Company.

In 1878, Leathers organized Company C of the Louisville Legion and became captain. He was later commissioned major of the First Regiment Kentucky State Guard by Governor Luke Blackburn of Kentucky, but he resigned his commission to raise a company of cadets for the same command, serving as captain of the company until 1888. He had to resign due to business affairs. While serving under Governor Blackburn, Leathers was a member of the committee of three to design a flag for the military banner of the Kentucky state troops.[137]

Leathers became a wealthy man, but he used his money toward a multitude of philanthropic endeavors. In 1895, he was a member of the executive council that planned and made all the necessary arrangements for the 1895 Grand Army of the Republic reunion in the Louisville. He was also treasurer. Because of his efforts, the 1895 GAR reunion was a huge success. He attended the Blue and Gray reunions at Gettysburg, and in 1913, he was appointed treasurer to help raise $500,000 to build the Gettysburg Peace Memorial. Because of his efforts in promoting peace after the war, the Army of the Potomac, an organization composed of officers who served in the Union army, made Leathers an honorary member. Leathers became the only Confederate soldier to ever to be given the honor.

He was also founder of the Masonic Widows and Orphans Home and the Old Masons Home in Shelbyville. For twenty-seven years, he was president of the Louisville Industrial School of Reform, which in 1920 merged with the Parental Home into the Louisville and Jefferson County Children's Home. He was also president of the Kentucky Humane Society, a member of the board of visitors at the Kentucky Military Institute and director of the Cook Benevolent Institute. He was secretary of the Kentucky School of Medicine and president of the Board of Trustees of the Second Presbyterian Church of Louisville.

In 1869, he was made a member of the Masonic fraternity. He was grand master of the Grand Lodge of Kentucky from 1875 to 1876. In 1879, he was grand treasurer of the Grand Lodge. He was also grand high priest of Royal Arch Masons and was a commander of the Louisville Commandery, No. 1, Knights of the Ancient Essenic Order.[138]

In 1869, Leathers married Katie Armstrong, who was the daughter of Charles and Amanda Armstrong. Charles Armstrong was a prominent pork packer who was intensely devoted to the Confederacy, sacrificed his entire fortune to the Southern cause and died in Atlanta during the siege in 1862. John and Katie had three sons: Charles, John and Stuart.

Leathers was also president of the Confederate Association of Kentucky. The group's promise was to "pay a decent respect to the remains and to the memory of those who died." The organization raised $7,500, which went toward relief and memorial work. Leathers gave serious consideration to help any Confederate veteran who was in need. For example, an ex-Confederate soldier named Sergeant Billy Beasley came to Leathers in 1889 seeking help for him and his daughter. Beasley had been injured in the Battle of the Wilderness and could barely walk. Leathers gave him a $2.00 stipend to help him and his daughter, a free apartment for six months and a $100 loan to open a cigar stand on the corner of Fifth and Market. When Beasley died in 1898, Leathers personally met the hearse carrying Beasley's casket at the entrance to Cave Hill Cemetery. Leathers paid for Beasley's funeral, cemetery plot, floral arrangements and headstone. He was also on a committee of five of the Confederate Association of Kentucky, which designed a button to be worn by Confederate veterans.[139]

Leathers continued to help his fellow ex-Confederate soldiers by becoming president of one of the largest United Confederate Veterans camps in the country. He was also instrumental in helping to establish a Confederate Veterans Home on 421 East Chestnut Street in Louisville.

On June 29, 1923, Leathers's long career in business and philanthropy came to an end. More than twenty members of his family attended his funeral. As the procession left the church and entered the gates of Cave Hill Cemetery, more than two hundred uniformed boys from the Industrial School, including the battalion of which Leathers had been an honorary member, met the hearse and led a long file to the grave site. First came the regiment, then the pallbearers and behind them the Knights of the Templar in white plumed hats and silver scabbards. Fourteen of them were on either side of the hearse. Masons of the Falls City Lodge, of which Leathers was a member, took charge of the service. The funeral service was led by T.J.

Adams, superintendent of the Masonic Widows and Orphans Home. Up and down the long drive, the boy soldiers stood with their guns at rest. At the top of the procession, their colors waved. Taps was played at his grave site as the casket was removed from the hearse and placed in the grave. He was buried in Section O, Lot 210.[140]

CHAPTER 19

JAMES BRIDGEFORD

Stoves

James Bridgeford was born on November 6, 1807, on a farm that occupied the Central Lunatic Asylum at Anchorage, Kentucky. His father was Thomas Bridgeford, and his mother was Harriett Smith Hite, of Maryland, a descendent of Betty Martin, famous in the English court.

When only thirteen years old, James left school and was apprenticed to his brother-in-law, John H. Bland, of Louisville. Bland owned a copper and street iron shop. During the five years of his apprenticeship, James familiarized himself with all the practical details of his trade and became a skillful workman. At the end of his term as an apprentice for Bland, he started on a prospecting tour through the South. He traveled to New Orleans, Natchez, St. Louis, Savannah and other cities but returned to Louisville with the impression that Louisville had as promising a future as any other southern city. During his four years in traveling the South, he familiarized himself with the methods of work in other cities, and he brought back with him a great deal of needful knowledge. He returned to Louisville in 1829 after accumulating a small amount of money. He planned to use the money to start his own business.[141]

In 1831, he married Arabella Hanson of Lexington, Kentucky. They had one son and three daughters. William Bridgeford became superintendent of the foundry and later vice-president. One daughter, Belle Bridgeford, married Confederate colonel Philip Lee, who was a member of the Kentucky Orphan Brigade and later became the leading prosecuting attorney in Louisville. Another of his daughters married Clark A. Smith of New York.

James Bridgeford monument at Cave Hill Cemetery, Louisville. *Courtesy of the author.*

Bridgeford's first venture into business was with Mr. Cocks, under the firm of Cocks and Bridgeford, dealers and workers in copper, sheet iron and so on. The firm lasted five years, and Bridgeford started another firm called Bridgeford, Ricketts and Company, with James Bridgeford as the senior partner and manager. Four years later, the firm of Wright and Bridgeford was organized and became one of the best and most widely known firms in Louisville. The store on Main Street, between Fourth and Fifth Streets, was a landmark in the city.

In 1842, the firm specialized in manufacturing stoves. James Bridgeford was manager of the firm, and with his attention to detail, he not only manufactured the stoves but also sold his other wares and was mainly instrumental in building up a trade that soon ranked as one of the first importance.

In 1856, he bought out Mr. Wright's interest in the firm and organized the firm of Bridgeford and Company, taking into business as junior partners some of the more industrious and intelligent employees of the old firm. The business was constantly enlarged, and the manufacture of stoves, ranges and grates was added to the company. The important industry of making copper and iron vessels, particularly for use on steamboats, was also added to the line of manufactured goods made by Bridgeford. The importance of river trade before the railroad and the number of boats landing at Louisville gave the firm an opportunity to take advantage of, and it soon became the largest manufacturer of copper and iron vessels in the South or West. His largest business still came from the manufacturing of stoves.

His business became too large for the Main Street location, and Bridgeford established a warehouse, furnace and shops below Main Street between Sixth and Seventh Streets, occupying almost an entire block, bounded by Water Street.

James Bridgeford was a charitable person and helped the poor people who lived on the riverfront, near his shops. In 1858 and 1861, he was a member of the city council. All his business interests were confined to Louisville. When the National Bank was organized, he was elected president. He was the leading director in many important corporations.

On June 12, 1881, James Bridgeford's son, James Bridgeford Jr., was getting out of the buggy with his father when he was struck with paralysis in his right arm. He was taken to his father's home on Broadway, between Fourth and Fifth Streets. He retired to bed, but his illness turned for the worse and he lost consciousness. He died a week later. He was only thirty-two years old. He was educated at the Kentucky Military Institute and graduated with high honors. Most of his life was spent in his father's business. His father made him a member of Bridgeford and Company. The death was a complete shock to his father. His brother William Bridgeford, who was living in Galveston, Texas, had to be summoned for the funeral.

James Bridgeford died on July 14, 1884. His funeral took place from the Christ Church, Second Street near Green. The services were held by Reverend J.G. Minnigerode, of the Cavalry Church; Reverend Dr. Perkins of St. Paul's Church; and Reverend Charles Ewell Craik of Christ Church.

James Bridgeford advertisement for his stove. *From Elstner's* The Industries of Louisville, Kentucky and of New Albany, Indiana *(1887).*

His pallbearers were John Green, Garvin Bell, C.T. Collins, Clinton McClarty, C.J. Walton, Thomas Maize, W.L. Lyons and Worthington Robinson. His honorary pallbearers were Samuel Churchill, John M. Robinson, John Moore, J. Kinkead, R.A Robinson, W.D. Taggert, A.G. Brannin, George Allison, Henry Churchill, J.W. Irvin, J.M. Armstrong, M.L. Belknap and J.M. Hollway.

After the church services, the funeral procession was formed, and the cortege made its way to Cave Hill Cemetery. A number of omnibuses, draped in mourning, contained the employees of the Bridgeford stove works, which were followed by ten carriages containing active and honorary pallbearers; finally, the hearse and around forty carriages with the family, friends and relatives ended the procession.

Arriving at the cemetery, the 130 employees formed in double rank, facing inward, and stood uncovered until the body and mourners had passed through, after which the ranks were closed and followed to the burial plot. A marble shaft, on a huge die block, was surmounted by a Corinthian cap, on the entablature of which stands an angel with a trumpet in one hand, ready to herald the arrival of the dead on Judgment Day. The base of the shaft is supported by two angels, one on either side, and for one the die block is cut to display the following scriptural inscription taken from the burial services of the Episcopal Church, expressive of the Christian faith: "Behold, I show you a mystery. We shall all not all sleep, but we shall all be changed. Then shall be brought to pass the saying that is written, Death is swallowed up in victory."[142]

At the foot of the memorial stone was dug the grave that was to receive the body of the deceased. The employees laid wreaths and bouquets of flowers at the grave. Conspicuously planted at the head of the grave was a cross about seven feet high, composed of magnolia leaves and surmounted by a crown of white immortelles, which in turn bore a smaller cross. The center of the cross, where the arms joined, was embellished with a large bouquet of pink roses and other flowers. At the foot of the frame, on an easel, was a workman's emblem: an arm and hand holding a hammer. Bridgeford's sister and the widow of John B. Bland, who was ninety-one, watched from the carriage, which stood only a few feet from the grave. The United States flag was lowered at half-mast at city hall tower in respect for Bridgeford, and fire bells rang at short intervals proclaiming to the people of Louisville that the body of Bridgeford was about to be laid in his tomb.[143] He is buried in Section D, Lot 69.

On August 13, 1889, James Bridgeford's last will and testament was offered, proven and ordered into the record in the County Court. His estate was worth $500,000 (today $10,645,180). His wife was given $10,000 with an annuity of $1,500 per year. He left his granddaughter Bella Loyd $10,000 to be held in trust until she became of age or married. He left Maggie Lee, his granddaughter, $2,000 and another $1,000 to her sister, Annabelle. He also gave $1,000 to each of William Bridgeford's daughters.[144]

All the rest of his estate was to be divided into two equal portions. One half was to go to equal portions to Belle Blanche Lee, Mrs. Julia Bridgeford Smith, Miss Dora Bridgeford and William Bridgeford. The other half was to be collectively held in a trust by them. His palatial residence on Broadway, between Fourth and Fifth Streets, was to be sold by the executors of the will.[145]

JAMES BRECKINRIDGE SPEED

Cement/Telephone/Wool

J ames Breckinridge Speed was born on January 4, 1844, in Booneville, Cooper County, Missouri. His father was William Pope Speed, a son of Judge John Speed, who built the Farmington plantation. His father was a well-known merchant in Louisville who moved to Missouri in 1842. William Speed became a friend of George G. Vest, the United States senator from Missouri. His mother was Mary Ellen Shallcross, who was the eldest daughter of Captain John Shallcross. She died when James Speed was only a boy.[146]

At the age of eleven, James Speed moved to Louisville and made his home with his aunt, Lucy Fry Breckinridge. He attended the grade schools in Louisville and graduated from the Louisville High School. His classmates included Judge James Pirtle and Judge Charles Seymour.

After graduating from high school at the age of sixteen, he gained employment as a clerk in the banking house of A.C. and O.F. Badger. He moved to Chicago to work in the office of Badger and Company. He was working at the firm when the Civil War broke out. He enlisted with the First Ohio Battery and was later transferred to the Twenty-Seventh Kentucky Union Volunteer Infantry Regiment and became an adjutant.

The Twenty-Seventh Union Volunteer Infantry was organized at Rochester, Kentucky, on March 21, 1862, under the command of Colonel Charles D. Pennebaker. The Twenty-Seventh Kentucky fought at the Battle of Shiloh on April 7, 1762, and participated in the Siege of Corinth, Mississippi, from April 29 to April 30, 1862; the occupation of Corinth on May 30; and the

Left: James Breckinridge Speed. *From Johnston's* Memorial History of Louisville from Its First Settlement to the Year 1896 *(1896)*.

Below: James Breckinridge Speed monument at Cave Hill Cemetery, Louisville. *Courtesy of the author.*

pursuit of the Confederates forces to Booneville from May 31 to June 12, 1862. The Twenty-Seventh Kentucky participated in Union general Don Carlos Buell's campaign in northern Alabama and middle Tennessee from June to August 1862. It participated in the Battle of Perryville, Kentucky, on October 8, 1862. On November 24, 1862, the regiment was ordered to Munfordville, Kentucky, and did post duty guarding the Louisville & Nashville Railroad until September 1863.

The regiment participated in Union general Ambrose Burnside's campaign in eastern Tennessee from October 4 through October 17. From November 4 through December 23, 1863, the regiment participated in the Knoxville Campaign. From November 17 through December 5, the regiment participated in the Siege of Knoxville. On May 23, 1864, the regiment joined Union general William T. Sherman's Atlanta Campaign. The Twenty-Seventh Kentucky fought in the Battles of Dallas, New Hope Church and Allatoona Hills from May 25 through June 5. The regiment fought at Marietta and Kennesaw Mountain from June 10 through July 2. The regiment also assaulted Kennesaw Mountain on June 27. It participated in the Siege of Atlanta from July 22 through August 25, 1864. The men fought in the Battle of Jonesboro from August 31 to September 1, 1864. After the Atlanta Campaign, the regiment participated in the operations against Confederate general John Bell Hood in northern Georgia and northern Alabama from September 29 through November 3, 1864. On November 14, 1864, the Union command ordered the Twenty-Seventh Kentucky to perform duty at Louisville and at Owensboro, Kentucky, and it fought against guerrillas until the men were mustered out in March 1865.

After the Civil War, James Speed returned to Chicago, but he soon moved back to Louisville. He obtained a job as a general superintendent with the Louisville Hydraulic Cement and Waterpower Company, which was organized in 1866 and later became the Louisville Cement Company. After a few years, he acquired a vast knowledge of the business. In 1892, Dr. W.B. Caldwell, the first president of the Louisville Cement Company, died, and James Speed was elected president of the company.

During the 1870s, the firm of Byrne and Speed, which was a dealer in coal, was established largely through James Speed's efforts and capital. The company at first did not operate on an extensive scale, but after a few years, it became recognized as one of the most substantial coal companies in the state. The coal was acquired through a few large mines in the Jellico district owned by the North Jellico Coal Company—one mine in the Western

Kentucky district owned by the Taylor Coal Company and two or three other mines also in the Western district owned by Williams Coal Company. James Speed was at the head of each of these companies.

In 1870, James Speed organized the firm of J.B. Speed and Company, with the main office located at 325 West Main Street. The company dealt in salt, lime and cement. Speed was president of the firm until June 1909, when on account of the steadily growing business, the company decided to file articles for incorporation. The capital stock was placed at $30,000. James Speed had 160 shares in the company, and his son William Speed had 150 shares, while Henry Gray, who was secretary-treasurer, had the remaining 3 shares. James Speed retired as president and the stockholders elected William Speed president and James Speed as vice-president.

In 1877, James Speed organized the American District Telephone and Telegraph Company. He was at the head of the company for a year or two before the company was reorganized as the Ohio Valley Telephone Company. Speed was also one of the original incorporators of the Louisville Woolen Mills Company. He served as president of the company from 1898 to 1903, when he resigned. He later sold the business.

Sometime before 1890, James Speed played an active part in the organization of the Louisville Cotton Mills Company. He was chosen as first president of the company. After serving as president for six or seven years, he resigned to accept the office of vice-president.

In 1890, James Speed fought hard to merge the Louisville City Railway Company property with the property of the Central Passenger Railway Company. When the two companies were consolidated, the new company was called the Louisville Railway Company. The board elected Speed president of the consolidated company, and he ran the company for ten years. Under his administration, the company thrived, but the demand on his time was so great that he was compelled to resign. The office of chairman of the executive board was created for him, and he served until his death. Speed was also director and largest stockholder in the German Bank and the Federal Chemical Company.

In March 1911, Speed presented the State of Kentucky a costly bronze bust of Abraham Lincoln. The bust, which stands in the rotunda of the new capitol in Frankfort, was dedicated in November 1911.

James Speed was also a member of the Pendennis Club. He was known in art circles as an excellent judge of paintings. He owned a large private collection of oil paintings worth thousands of dollars. His last financial transaction of any magnitude was the formation of the Louisville Railway

Company for the building of lines to interurban points, which led to the formation of the Louisville and Interurban Railway.

He was twice married. He married his first wife, Cora Coffin, in 1867. He had three children by her: William Shallcross, Olive Sackett and Douglas Breckinridge, who died in infancy. Following the death of Cora on March 10, 1905, James Speed married his second wife, Hattie Bishop, on July 4, 1906.

On July 7, 1912, James Speed died at the Hotel Samoset, Rockland Breakwater, of Bright's disease and heart trouble. He had been suffering from Bright's disease for several years and came to Rockland, Maine, to spend the summers. After his death, his body was taken back to Louisville. The funeral services were held at the Church of the Messiah (Unitarian), located at Fourth and York. When he died, James Speed was a multimillionaire. After his funeral services, he was laid to rest at Cave Hill Cemetery, Section 1, Lot 203.[147]

In 1925, Hattie Bishop Speed founded the J.B. Speed Memorial Art Museum, now known as the Speed Art Museum, as a memorial to her husband. On January 15, 1927, the museum opened its doors. The building was designed by famous Louisville architect Arthur Loomis. In 1925, James Speed's children, William and Olive Speed Sackett, founded the J.B. Speed Scientific School, now known as the J.B. Speed School of Engineering, at the University of Louisville in honor of their father's memory.

JAMES B. WILDER

Druggist

J ames B. Wilder was born in Maryland in 1817. When he was ten years old, his mother, who was a widow with three sons, decided to move to Missouri. When she was on her way to Missouri, she stopped in Louisville, Kentucky, because some of her slaves fell ill. While staying in the city, she fell in love with it and decided to stay and make Louisville her permanent residence.

While a young boy, J.B. Wilder went into the drug business as a clerk. His brothers Edward and Oscar also entered into the drug business. Around 1848, his brothers established a separate business for themselves under the name Wilder Brothers. The business was very successful from the very start. When Oscar Wilder died, the company was changed to J.B. Wilder & Company. On August 28, 1852, a reporter from the *Louisville Journal* was given a tour of the massive storehouse by J.B. Wilder and his brother Edward. Starting at the cellar and going through the four stories, the reporter noted, "One can hardly imagine that so large a quantity of drugs, chemicals, paints, oils, and dye-stuffs, as you then find yourself surrounded with would be sufficient to supply the whole Union, not thinking for one moment that such as enormous quantity as this is sold in only a moiety of the goods sold by this firm as they are daily receiving large supplies."[148]

The reporter stated that the building on 181 Main Street was elegant, with a Gothic front, which was the only one in the West at the time. The building was covered with elaborate molding and stone, which was acquired from Indiana. The sky light was immense and beautiful. John Stirwalt was

the architect who planned and constructed the building. The beautiful block letters in front of the building were painted by W.G. Miller.

Graham Wilder, J.B. Wilder's son, became a partner in his firm. J.B. became one of the largest wholesale druggists in the country. He was progressive and aggressive in his business pursuits, and his great energy and excellent judgement made his business very successful.

J.B. Wilder was not just content with running a drug company; he also decided to expand into other businesses. He became interested in the Louisville, Cincinnati & Lexington Railroad, and the board of directors of the railroad elected Wilder president. Wilder held the position for many years. He eventually sold the railroad to the Louisville & Nashville Railroad for $400,000. He continued to be a stockholder in the railroad. He was director of both the Louisville & Nashville Railroad and of the Bank of Louisville. He was also a trustee of the University of Louisville. Wilder was interested in the manufacturing of jeans and wool and became president of the Falls City Jeans and Wool Company. He was also vice-president of the Louisville Insurance Company.

Wilder also became involved in real estate and built the elegant store at Sixth and Main Streets owned by J.M. Robinson Norton and Company. He also built numerous other costly buildings, such as the building at Fifth and Main Streets, occupied by the First National Bank. The property of David Baird and Sons Company, located on Main Street between Fifth and Sixth Streets, was also owned by J.B. Wilder. He also had other business and residential property throughout the city. At the time of his death, his real estate holdings were valued at between $250,000 and $300,000. His total estate was estimated at about $750,000 ($18,690,139.27 today).

Unfortunately, death was following Wilder all his life. At the time of his death in 1888, he had already lost his wife, mother and all his immediate relatives, except for his brother Edward and his nine grandchildren. His only daughter married Professor L.H. Hast. When she died, she left four children, all of whom were still living at the time of his death. His son, Graham, had died years earlier and had left five children, who were also living at the time of Wilder's death.[149]

J.B. Wilder died on May 17, 1888. He was staying at the residence of his daughter-in-law, Edith Wilder, on 1826 Fourth Avenue. He had returned from a trip to Kansas, where he had considerable interests, and when he arrived in the city, he went to his store. After visiting his business, he had dinner with Edith. Shortly after his meal, he stated that he would lie down and take a nap. He slept on one of the sofas on the first floor. Around 1:00

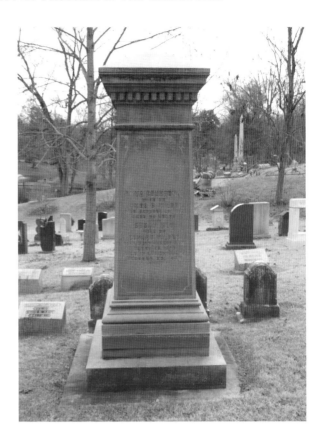

Right: James B. Wilder movnument at Cave Hill Cemetery, Louisville. *Courtesy of the author.*

Below: James B. Wilder advertising card from the Southern Exposition. *Courtesy of the author.*

p.m., Mrs. Wilder sent one of her children to wake J.B. The child returned stating that she could not wake grandpa. Mrs. Wilder found J.B. Wilder dead. He had not been in good health for some time.[150]

James B. Wilder's funeral was held at Christ Episcopal Church, and his personal and business friends followed his body from the church to Cave Hill Cemetery. He was laid to rest in Section F, Lot 489. The pallbearers were J.M. Robinson, Charles M. Miller, C.R. Hewitt, John Carter, R.A. Robinson, John Otter, John Barrett and John Cooper. In his will, J.B. Wilder named Edith Vaughan Wilder, the widow of his son, Graham Wilder, as executrix of his estate, with the provision that in case of her death, or marriage, the Louisville Trust Company would became the trustee of the estate. On June 12, 1907, Edith married Reverend Roger Hanson Peters of Kalamazoo, Michigan. The trust company took over the active management of the estate. H.V. Loving, president of the Louisville Trust Company, stated that Wilder's estate was valued at between $600,000 and $700,000, and the real estate contained some of the best property along Main Street.[151] Mrs. Peters did an excellent job increasing the value of the real estate. She had the Louisville Trust Company as an agent, so when the company became the trustee, there was little change in the duties of the trust company in the management of the properties.[152]

DR. JOHN BULL

Sarsaparilla/Real Estate

Before the passage of the 1906 Pure Food and Drugs Act that prohibited interstate commerce in adulterated and misbranded food and drugs, many companies concocted remedies that they claimed would cure every ailment. Dr. John Bull was one of those men who made a fortune selling elixirs, bitters and pain medication and became known around the world for his sarsaparilla elixir.

In 1813, John Bull was born near Simpsonville, Shelby County, Kentucky. At the age of twelve, Bull moved to Louisville and became a porter in Hyers and Butler's drugstore and studied medicine under Dr. Shrock. In 1837, he opened his own store, which closed two years later. He eventually became a prescription clerk for the wholesale drug firm of James B. and Edward Wilder & Company. After gaining an intimate knowledge of the character of drugs, he discovered the sarsaparilla remedy that would become the foundation of his fortune. When he first began the preparation of his remedy, he would carry to his home in a basket the ingredients necessary for the preparation, and after having gone through the necessary manipulations at home, they were returned in bottles to the drugstore. The drugstore allowed him to use a corner of one of the store windows to display his sarsaparilla remedy.[153]

By 1845, Bull was in partnership with Robert Bower manufacturing his company's tonic syrup. By 1847, Bower had left the company. By 1850, Bull had begun to market his sarsaparilla in Kentucky and other states. In July 1854, Bull decided to move to New York and set up another factory to expand

Left: John Bull obelisk monument at Cave Hill Cemetery, Louisville. *Courtesy of the author.*

Opposite: *John Bull Almanac. Courtesy of the United States Library of Medicine digital collections.*

his business. Bull stated that he needed a central position for the proper shipment of his "articles of medicine to the four corners of the world,"[154] and he thought New York had the greater facilities for "the transaction of a cosmopolitan trade than any other of the earth's greatest cities."[155] His business partners would superintend the western department, while Bull would make himself "King of Disease in all the Orient."[156]

In 1856, he published a *United States Almanac* in which he extolled the "great efficacy and almost miraculous curative powers of his Sarsaparilla." He published testimonials in his almanac that his sarsaparilla remedy cured erysipelas, chronic sore eyes, ringworm, rheumatism, pains in the bones or joints, disease of the kidneys, ulcers, bronchitis, sore throat, coughs, colds, jaundice, headaches and night sweats—list goes on and on. He even backed up his claims with testimony from medical doctors. According to B.B. Allen, MD, who was a graduate of Transylvania Medical University, he had practiced "medicine in this wilderness country about five years, but owing to exposure to bitter cold weather, I have been indisposed with acute Rheumatism about six months. After having exhausted my skill in the treatment of my case, and derived no benefit, I was induced to give

DR. JOHN BULL'S

UNITED STATES ALMANAC

FOR THE YEAR OF OUR LORD

1856.

Prefatory Remarks by the Proprietor and Publisher.

In issuing this present number of my UNITED STATES ALMANAC for the year 1856 to the public, free of any charge, I feel constrained to give some explanatory reasons for so doing. The book is full of scientific, useful, and daily practical information alike to the Farmer, the Man of Science, the Merchant and the Mechanic, one and all can find some information in it, suited to each and every of the 365 days of the coming year, the eightieth year of our glorious Independence, 1856.

My object in distributing this Almanac to the "Millions," free of charge and at great cost to myself, is not merely to inform them of the day of the Month, Changes of the Moon, Moveable Feasts, and High Church days, but also to put them in possession of more important and philanthropic information of how they may obtain and use the most effectual and valuable medicinal remedies ever produced in the known world,—remedies which have saved many valuable lives and will doubtless under Providence save many more to future years of usefulness and joy to their families, themselves and the communities in which they may reside. All I ask then is that you read and ponder well the excellent virtues of these remedies, and if your neighbor has no such Almanac, get him one or lend him yours; not forgetting freely you have received, freely bestow.

Ever remaining the People's friend and devoted servant,

JOHN BULL,
late of Louisville, Ky

New-York, Sept. 1st, 1855.

your Fluid Extract of Sarsaparilla a fair trial, and accordingly purchased a bottle of your medicine…and I must confess that one bottle has entirely cured me."[157]

Bull's adventure in New York was a complete failure, and he lost $10,000 in the venture. He decided to return to Louisville and expand his business venture there. By 1860, he was employing fifteen men. His factory was located on Fifth between Main and Water Streets in Louisville. His proceeds were equally divided among his pills, sarsaparilla and anti-worm product. The Civil War did little to help his profits, and by mid-1861, the sheriff had seized his factory and stock. He was so desperate for money that he became a federal provost marshal.[158]

His misfortune did not last long. Bull rebuilt his business, and by 1868, his taxable income was $132,963. By 1870, he was one of the wealthiest men in Louisville. By 1874, had he sold between $400,000 and $500,000 of his Dr. John Bull's Compound Fluid Extract of Sarsaparilla, Dr. John Bull's Balsam of Wild Cherry and Iceland Moss, Dr. John Bull's King of Pain, Dr. John Bull's Vegetable Tonic Pills, Worm Destroyer, Smith's Tonic Syrup and Dr. John Bull's Compound Cedron Bitters and was employing fifty men in his factory. His office was located on Main Street located between Eighth and Ninth Street. He had another office located near the Fifth Street factory.[159]

On April 26, 1875, Dr. John Bull passed away at his home on Broadway and Floyd Street. He had been suffering for six months from "congestion of the brain" He was a heavy smoker, sometimes smoking fifteen or twenty cigars a day, but days before he died he decided to stop smoking entirely. According to the *Louisville Courier-Journal*, "it may be the lack of the stimulus deferred from the cigars that hastened his death."

According to the *Louisville Courier-Journal*, Bull's property was worth $750,000 in real estate, bonds and so on. If you figure in the rate of inflation, in today's money, Bull would have been worth $9,855,000. Bull Block was one of Market Street's landmarks and named after John Bull, as he helped fund most of the businesses on that block. His home was one of the most elegant sites on the street. At Bull's funeral, he had two Masonic temples attending. More than sixty carriages followed his casket to Cave Hill Cemetery. He was laid to rest in Section F, Lot 93. He was married to Mary Ann Batchelor and had four children.

CAPTAIN DANIEL PARR

Real Estate

On December 12, 1825, Daniel Parr was born in Alsace, France. His father served under Emperor Napoleon Bonaparte and was one of the survivors of the Battle of Waterloo. Napoleon awarded his father with the decoration of the Cross of the Legion d'Honneur. In 1820, Daniel's family left France for America and settled on a farm in Kenton, Kentucky. Daniel's father eventually bought a farm near Lawrenceburg, Indiana.[160]

Daniel received only a six-week education, but he had a natural capacity for self-education. Daniel's father was heavily in debt with his farm, so he sent Daniel to Louisville at the age of fourteen to obtain employment on the steamer *Pensacola*, under the command of Captain Lowdwick. He made his first trip on the steamer to New Orleans, and when they arrived in the city, they found it infected with yellow fever. Many of the boat's crew and employees abandoned the steamer in order to leave the city. Daniel Parr stayed on the steamer and remained at his post. By the end of the season, Daniel had accumulated a large sum of money. He shared his earnings with his father, sending him various amounts from each trip, until $2,000 had been sent, which allowed his father to pay off the debts.[161]

Before he was twenty-one years old, Daniel Parr had accumulated $6,000, and with his money, he built and outfitted the steamer *Duroc*, along with Captain Valentine Jordan. The steamer was completed in the fall of 1847. On its maiden voyage, the steamer was involved in an accident

 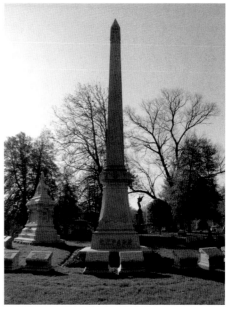

Left: Captain Daniel Parr. *From Johnston's* A Memorial History of Louisville.

Right: Daniel Parr obelisk monument at Cave Hill Cemetery, Louisville.

in which the ship almost sank. Daniel Parr and Captain Jordan brought the steamer back to Louisville, began repairs and reloaded the ship. The steamer sailed to New Orleans, but the delay and repairs had cost Daniel $5,000. A second trip proved unfortunate and cost Daniel Parr another $2,000. Debts forced Daniel to sell the steamer at the sheriff's auction, and fell short of the $7,000 needed to pay off the full debt. To make matters worse, Captain Jordan died and left Daniel to inherit the entire debt. From that point onward, Daniel Parr decided to conduct business on his own with no business partners.[162]

In 1847, Daniel married Maria G. Marmaduke of Oldham County. She was the daughter of Sampson Marmaduke, who was one of the pioneer settlers of Fayette County, Kentucky. They had six children during their marriage.[163]

In 1848, Daniel Parr borrowed another $600 and built a side-wheel steamer, which he named *The Julia* in honor of the daughter of William Pragoff, who gave Daniel the money. He ran the steamer himself and made enough money at the end of the season to pay off the steamer; he sold it for $8,000, which essentially paid off all his debts.[164]

After selling off *The Julia*, he built a stern-wheeler called the *Tempest*, which he ran for three years, until the ship was lost. He purchased the *W.W. Crawford*, ran the ship for several months and then sold it. He purchased a government boat and named it *Tempest Number 2*, and after he sold the steamer, he built the *Tempest Number 3*. He eventually acquired twenty boats, which sailed up and down the Mississippi and Ohio Rivers.[165]

During the Civil War, Daniel Parr used his fleet of steamers to transport people and goods on the rivers. During Kentucky's neutrality in 1861, he transported Confederate and Union supplies and men, but when the Union government took control of the Ohio River in 1862, he catered to the interests of the Union but did not hide his sympathies with the South. During the Battles of Fort Henry and Donelson in February 1862, the government needed steamers and boats to transport men and material. The Union government wanted to use Parr's newest steamer. Since Parr was a Southern sympathizer, he refused to allow the Union government to use his steamer. The Federal government arrested Parr, threw him in prison, seized his newest steamer and used the boat to transport the troops to Fort Donelson. Daniel Parr spent six weeks in prison for his refusal to allow Federal troops to use his steamer. In 1863, Captain Parr's thirteen-year-old daughter, Virginia, was aboard one of her father's steamboats at the Louisville wharf. Nearby, Confederate prisoners were on a transport steamer ready to depart for the Northern prisons. Virginia saw how the Confederate prisoners were only wearing tattered clothing and had not been fed. She stood at the gangway of the Federal-controlled wharf asking all who passed by if they would donate money to benefit the prisoners. The Union soldiers patrolling the wharf must have been shocked when they saw Parr's daughters asking for money, but she managed to collect a "handsome sum" of money.[166]

After his experience being imprisoned, his ship seized by the Union government and becoming disgusted with the river traffic, which was hampered by the Union government war vessels sailing on the Mississippi, Parr decided to sell his entire fleet of boats, vowing never to return to sailing the rivers. By the end of the war in 1865, he had become one of the original founders of the Louisville and Jeffersonville Ferry Company. He also owned half interest in a steamer called *Palestine*. In 1866, he sold all his interests in river transports, ending his chapter of riverboat life.[167]

With his vast fortune, he decided to improve and beautify the city while continuing to expand his wealth. On Fourth Avenue, he built four store buildings, and in 1869, he built the iron-front block adjoining the street to the south. In 1872, he built a home on 408 West Chestnut Street, and in

1875, he built three stone-front homes at the corner of Floyd and Walnut Streets. Later, he built a stone-front store on 218 Fourth Avenue. Parr lived with his family in the home he built on Walnut Street, but later he built a home on Chestnut Street. He lived there for twenty-seven years. In 1887, he built business block 622 and 624 on Fourth Avenue. Daniel Parr became one of the largest property owners and wealthiest citizens in Louisville. All of the buildings were erected under his direct supervision, and he drew up the plans himself. He was one of the leaders who built up the principal retail street of the city at the time and became known as the "Pioneer of Fourth Avenue." His large tract of property became the retail center of the city and became one of the most valuable pieces of property in the city. He had an unusual foresight in buying property and seemed to be able to locate exactly where the next property would become valuable.[168]

For twenty-five years, Parr was one of the directors of the Bank of Louisville and helped to make the bank one of the leading financial concerns in the Southwest at the time. By the age of seventy-six, he had amassed a huge fortune, so he decided to use his money for philanthropic purposes. His daughter Virginia, who was sympathetic to the Confederate cause, wanted her father to contribute to a new project proposed by ex-Confederate soldiers. She arranged for a meeting on Fourth Street between her father and Lieutenant Bennett Young, who during the Civil War had ridden with Confederate general John Hunt Morgan. During the meeting, Daniel Parr told Young that his daughter was living with him and no longer in need of a place of her own. Parr wanted to return the property back to his name and then donate it to the Confederate Association of Kentucky. Young told Parr that the house would become a Confederate veterans home. On April 15, 1901, Young and Parr met at the county clerk's office, where they signed over the deed to the home to the Confederate Association of Kentucky. Daniel Parr selected nine trustees for the property. He signed over the house and lot at 421 East Chestnut Street. The home was valued at $55,000 and had fourteen rooms. According to the terms of the deed, the trustees were to use the house or the proceeds from the sale of the house for the purpose of securing and maintaining a home for Confederate indigent and disabled soldiers from the state of Kentucky. Within eighteen months, Bennett Young was able to open the Confederate Veterans Home. Later, the home was sold, and the Confederate Veterans Home was located in Pee Wee Valley.[169]

On August 16, 1901, Captain Daniel Parr gave the Immanuel Baptist Church in Petoskey, Michigan, property valued at $20,000. A new church

would cost at least $16,000 and would be called Parr Memorial. Parr visited Petoskey for eleven years. His wife had died several months earlier, and the church would be a memorial to her. Parr gave $533 to pay off the church mortgage. Captain Parr also told the local papers that the gift would "support and build up the Baptist cause in Petoskey."[170]

Captain Daniel Parr was also a member of the Walnut Street Baptist Church in Louisville, Kentucky, and was a trustee. He was also the trustee for the Baptist Orphans Home. He also made large donations to the Home of the Friendless and the Orphans Home. The Parr Memorial chimes at the Walnut Street church were a memorial to his late wife and cost $10,000.[171]

On January 20, 1904, Daniel Parr passed away peacefully in his daughter Mrs. John Sale's home. He left an estate worth $600,000 (about $15,867,546 today). His real estate alone was valued at $500,000. His family home at 408 West Chestnut was valued at $10,000 (about $264,459 today). He was survived by three children: Mrs. John Sale, Mrs. William Marshall and William Parr. He also had four grandchildren: Marmaduke Parr Sale, Daniel Parr Marshall, William Marshall Jr. and Virginia Marmaduke Marshall. His funeral was held at the Walnut Street Baptist Church, and Daniel Parr was laid to rest at Cave Hill Cemetery, Section A, Lot 204.

Unfortunately, Daniel Parr left several wills. In 1907, a statement in Captain Parr's handwriting was found among his papers, and his heirs had the statement chiseled onto his monument at Cave Hill Cemetery. It indicated that Parr had a change of mind and decided that his entire estate should be left to his three children. Parr wrote a later will that he stated was in his safety vault box, but the will could not be produced. In 1926, his later will came to light, and the Kentucky General Assembly increased the statute of limitations forbidding the probate of a second will from five to twenty-five years. Judge Lafon Allen ruled that the legislature could not revive a right of action, and in 1929, twenty-five years after the probate, his judgement was upheld by the Court of Appeals.[172]

CHAPTER 24

JACOB LINDENBERGER

Financier

Ι n 1840, J.H. Lindenberger was one of ten children. He was born in Baltimore, Maryland, on November 13, 1824. The family had resided in Baltimore since 1780. In 1838, Jacob left school in Baltimore to come to Louisville to work for his brother. His older brother had already moved to and established a business. Jacob began his business career as a boy in a small position in the wholesale drug house of Rupert & Lindenberger, which was owned by his brother. He was paid only $12.50 per month. By 1846, he had advanced to the position of partner. Shortly after this, Rupert left the business, and Jacob and his brother were the remaining partners. They changed the name to Lindenberger Brothers. Jacob took a prominent position in the business and prospered. On July 1, 1861, he quit the mercantile business and entered banking as a cashier of the Merchant's State Bank, which was organized in 1860. Since he was familiar with the successful management of a mercantile industry, he was perfect for the management of a bank. The bank became quite prominent and popular among the bank's patrons, and more importantly, he made a profit for the stockholders.[173]

In 1874, the bank was merged with the national bank system and its name was changed to Merchant's Bank of Kentucky, and in July 1881, Lindenberger was made president of the bank. The bank was always prominent in promoting, through the use of its facilities, all legitimate commercial and manufacturing enterprises, and it had been an important factor in cooperation with other institutions in promoting the progress and commercial prosperity of the city of Louisville. The charter of the

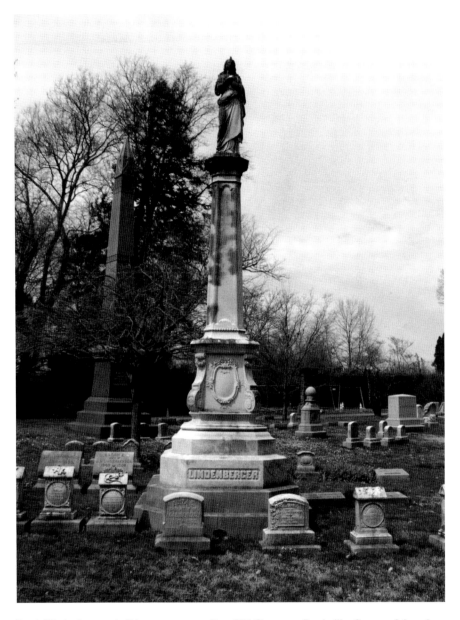

Jacob Lindenberger obelisk monument at Cave Hill Cemetery, Louisville. *Courtesy of the author.*

The Merchants Bank of Louisville, owned by Jacob Lindenberger. *From Elstner's* The Industries of Louisville, Kentucky and of New Albany, Indiana *(1887).*

bank was to run for twenty years, or until 1894, when the Merchants National, City National, Kentucky National and Second National combined to make the American National Bank, and again Lindenberger was made president.[174]

While he was president of the bank, he, along with several other businessmen, planned the Louisville Clearing House. He was one of five men who wrote the constitution and bylaws of the association. He was the organizer of the Southern Mutual Life Insurance Company, which changed its name to the Mutual Insurance Company. He was also director of the Louisville & Nashville Railroad and one of the men who assisted in forming the Louisville Board of Trade. He was also the first president of the Rock Gas Company. He was also promoter of the Norton Infirmary and assisted in forming the Fidelity Trust Company and Safety Vault Company, becoming its first president.[175]

In March 1885, the immense distilling property of the Newcomb-Buchanan Company went up for auction. The property was located in the eastern part of the city on Beargrass Creek and Hamilton Avenue and included the Nelson, Anderson, Monk and George Buchanan Distilleries and warehouses. About thirty acres of land was attached to the distillery, as well as a fine house and office that went with the Nelson distillery. There were forty or fifty distillers and capitalists in the audience, including Jacob Lindenberger. Each distillery was offered at auction separately. The Anderson Distillery and warehouses were the first to come to auction. Jacob bought the Nelson distillery for $15,000. The two distilleries were put up for auction together, and Jacob bought the Anderson and Nelson brands for $100,150. He also bought the George C. Buchanan Distillery for $13,000. Lindenberger was representing a

syndicate of creditors. He planned to hold the property until he could sell it at an advantage. He was going to lease the property since he had no intention of running the distillery himself.[176]

Jacob was also a member of the Salmagundi Club, which resulted in the Louisville parks system. He was married three times. His first wife was Mrs. Flusser, the second wife was Mrs. Peterson and his third wife was Sallie Gamble. His children were Charles Lindenberger, president of the Louisville Spirit Cure Tobacco Company; Mrs. Edward Townsend; Mrs. Harry Dumesnil; Sallie; Jennie; Kate Lindenberger; and Emory Lindenberger. He retired from the American National Bank in 1899.

Jacob died on January 22, 1900, at his home on 122 West Ormsby Avenue. He had bladder trouble for several years. The funeral took place at St. Andrew's Church, and his burial was at Cave Hill Cemetery, Section B, Lot 69. His pallbearers were George Bayless, Henry Orsmby, Herbert Lougbridge, Charles Bohzien, Henry Grant, J. Logan Gamble, John Sanders, and Charles Carter. His honorary pallbearers were Charles Warren, John Stites, H.V. Sanders, J.P. Vaughn, H.A. Dumesnil, C.F. Johnson, T.H. Tapp, John White and Dr. P.B. Scott. The directors of the American National Bank were also present at the funeral.[177] His will gave $25,000 to his wife, besides all his household property. She was also bequeathed $25,000 in a trust. At her death, the trust was to become part of the residuary estate. He also left one-tenth of the residue for life and directed her to have use of the dwelling at Second and Orsmby. The balance of his estate was left to his nine children. He willed that Mrs. Lindenberger was to be executrix with full powers to employ the Fidelity and Trust Company and Safety Vault Company. At the time of her death, the residuary estate was to go equally to the children.[178]

On July 4, 1906, Sallie Lindenberger, wife of Jacob, died of heart failure at the home of her son William Lindenberger in Canon City, Colorado. She had moved to Colorado in June 1906. Her body was taken back to Louisville, and she was buried with her husband at Cave Hill Cemetery.

JOHN MCFERRAN

Pork Packer and Father of the Rural School

John Byrd McFerran was born near Glasgow on September 29, 1836. At the age of twenty-one, he was married to Laura J. Ragland, who died in 1892. He spent his entire life in Louisville, Kentucky. He was the first president of the Louisville Board of Trade in 1880 and 1881. At the time, he was president of McFerran, Shallcross and Company, one of the first packinghouses in Louisville and known as the curers of the famous Magnolia Hams.[179]

In 1891, John Cudahy, who owned one of the largest pork production companies in the country, equal to the capacity of Armour and Company, did most of his meatpacking in Chicago and Milwaukee. However, he wanted to secure a meatpacking plant in Louisville. He purchased the Hughes, Taggart and Company pork house on the corner of Story Avenue and Pocahontas Street and bought McFerran, Shallcross and Company and its entire pickle casks. The Chicago firm would continue the Magnolia Ham brand and breakfast bacon in the old plant of McFerran, Shallcross and Company on the corner of Thirteenth and Maple Streets, until the capacity of Hughes, Taggart and Company could be increased and an additional plant be located in another part of the city. Cudahy paid $30,000 for the Hughes plant but did not release information on how much he paid for McFerran, Shallcross and Company. He also bought twenty-three acres of land south of the Kentucky Wagon Works, lying between the Louisville Southern and Louisville & Nashville railroad tracks. The land was owned by W.P.

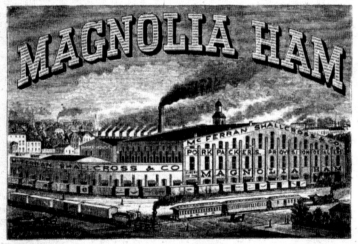

McFerran, Shallcross and Company advertisement. *From* 35th Annual Report of Pork Packing in the West and Elsewhere in the United States Accompanied with Provision and Grain Trade Statistics for the Year Ending March 1, 1884, *Charles Murray, Cincinnati, Ohio.*

Clancy, one of the members of the McFerran, Shallcross and Company and John McFerran's grandsons.

For twenty-eight years, the business of McFerran, Shallcross and Company was associated with Louisville and known for its quality pork products. The Magnolia Hams brand was established in 1863 by the firm of McFerran and Menefee, consisting of John McFerran, J.C. McFerran and R.J. Menefee. The brand was continued under the firm of McFerran & Armstrong and Company, when V.P. Armstrong was an active member of the company. The brand was changed to John McFerran, S.H. Shallcross, R.J. Menefee and W.P. Clancy. In 1863, only 7,500 Magnolia hams were cured, but by 1890, they were curing more 375,000 hams annually; by 1891, the firm was curing as many as 1 million hams per year. Cudahy promised that the capacity of his new plant would turn out from 750,000 to 1 million Magnolia hams per year. The only member of the family involved in the new plant under Cudahy control would be W.P. Clancy, who would manage the business.[180]

After Cudahy bought McFerran's plant, he devoted his life to the enduring interest of the betterment of the rural schools, which led him and four other wealthy men to give $20,000 for the creation of the first modern rural school in Kentucky, located in Midway. Following a report on the conditions in the rural schools, McFerran made a tour of inspection. He found the conditions worse than reported and immediately inaugurated campaigns for the betterment of schools. He visited other states to study methods, and as chairman of the State Educational Committee of the Board of Trade, he made a trip to the University of Wisconsin to gather material for use in Kentucky.[181]

The immediate result of his trip was the McFerran County Bond Bill, which enabled every county in the state to vote a bond issue for construction of new school buildings and modern equipment. He became known as the "Father of the Rural School." Before his death, his latest achievement in school improvements was instituting a series of community meetings under the management of the State Development Committee of the Board of Trade. The city of Louisville also benefited from McFerran's philanthropy, receiving about twenty acres of land along Creek Valley Road in Cherokee Park in Louisville.[182]

On January 10, 1883, John McFerran and his wife made a deed of gift to the Walnut Street church to spend $25,000 on a lecture room, provided the church would contribute $10,000 or more and that the material should be of stone. Before the lecture room was completed, the amount spent was

John McFerran monument at Cave Hill Cemetery, Louisville. *Courtesy of the author.*

more than $44,000, of which Walnut Street raised more than $19,000. The lecture room was dedicated on November 3, 1889. On January 23, 1890, McFerran Memorial Church was organized, and on August 6, 1890, the trustees of Walnut Street Baptist Church made a formal legal transfer of the property to the trustees of McFerran Memorial Church—the benevolent plan of John McFerran, the founder of the church, was at last completed with success.[183]

In 1907, John McFerran released the Fourth Avenue Baptist Church from all original conditions originally imposed on the church. He indicated that he would give the trustees of the church the title to the property, releasing the church from the payment to himself or his heirs of any part of his original donation toward founding of the McFerran Memorial Church and at the same time insisting that the church should at once take another name. On March 8, 1907, the name of the church was changed from McFerran Memorial Church to Fourth Avenue Baptist Church. On November 23, 1909, the cornerstone of the Fourth Avenue Baptist Church was laid at Fourth Avenue and Oak Street. The Oak Street part of the church was

the lecture room. The congregation was engaged in raising funds for the completion of the original plans of the structure for twenty years. A copper box time capsule was organized that consisted of the church manual history of the church, the covenant, articles of faith, constitution and bylaws, a list of membership, number of missions organized by the church, minutes of the last meeting of the Long Run Association, copies of the *Baptist World and Recorder*, copies of the *Louisville Courier-Journal and Herald*, a photograph of the church, a list of building committee members and a Bible. A few small coins were also put into the time capsule.[184]

On December 9, 1915, more than four hundred people gathered in the auditorium of the new John B. McFerran School, which was then located on 1515 Cypress Street. The twelve-room building cost $101,000. McFerran could not attend due to a severe cold. During the dedication, Dr. I.N. Bloom, president of the Board of Education, paid high tribute to McFerran and the great work he had done for not only the schoolchildren of Louisville but also the schoolchildren of the state. Bloom stated that the McFerran School was the only one named after a living man. Judge John C. Strother, formerly a member of the Board of Education, said that the school would stand always as a monument to the wise expenditure of a portion of the $1 million school fund and noted that the people of Louisville showed their appreciation of education when they voted in favor of McFerran's bond issue.[185] The John B. McFerran School received an addition in 1955, and the school was moved to the remodeled building of the Detrick Vocational School in 1996 and became the McFerran Preparatory Academy. The campus took the Detrick name. The Cypress Street site was sold in 1996, and the old school became the H. Temple Spears Assisted Living Residence.

John McFerran died on February 20, 1920. His funeral was held at his residence near Cherokee Park. He was survived by his two sons and two daughters: Calvin and Charles McFerran and Mrs. John Barr and Mrs. W.P. Clancy. He was also survived by nine grandchildren. He was buried at Cave Hill Cemetery, Section A, Lot 194. Five of his grandsons would become soldiers during World War I. They were Captain William Clancy, Captain John McFerran Barr, First Lieutenant Edwin Menefee Clancy, Second Lieutenant John McFerran Jr. (Aviation Corps) and Sergeant Watson Barr McFerran.[186] When he died, John McFerran was worth $300,000, and his real estate was valued at $50,000, all of which was left in equal parts to his four children and the children of his deceased son. He also contributed more than $100,000 to religious, charitable and educational institutions.[187]

Notes

Introduction

1. Cashman, *America in the Gilded Age*, 12.
2. Ibid., 26.
3. Ibid., 95, 143.
4. Elstner, *Industries of Louisville*, 14–16.

Chapter 1

5. Ibid., 14–16.
6. Ibid., 32.
7. Ibid., 39.
8. Ibid., 40.
9. Yater, *Two Hundred Years at the Falls of the Ohio*, 98.
10. Ibid., 97.
11. Allison, *City of Louisville and a Glimpse of Kentucky*, 21.
12. Elstner, *Industries of Louisville*, 24.
13. Ibid., 39.
14. Allison, *City of Louisville and a Glimpse of Kentucky*, 20.
15. Johnston, *Memorial History of Louisville*, 261.
16. Ibid.
17. Ibid., 262.

18. Huckelbridge, *Bourbon*, 64.

19. Ibid., 118.

20. Ibid., 119.

21. Ibid., 122.

22. Ibid., 126.

23. Allison, *City of Louisville and a Glimpse of Kentucky*, 16

24. *Louisville*, 18.

25. Thomas Watkins, "The Tobacco Trade of Louisville," from Johnston, *Memorial History of Louisville*, 251.

26. Ibid., 256.

27. Ibid., 259.

28. Allison, *City of Louisville and a Glimpse of Kentucky*, 17.

29. Ibid., 17.

30. Johnston, *Memorial History of Louisville*, 280–81.

31. Allison, *City of Louisville and a Glimpse of Kentucky*, 95.

Chapter 2

32. Johnston, *Memorial History of Louisville*, 624.

33. *Louisville Courier-Journal*, "John G. Baxter Dead: Sudden Death of the Ex-Mayor at Hot Springs, Arkansas Yesterday," March 31, 1895.

34. Ibid., "The Funeral Arranged: The Late Ex-Mayor Baxter to Be Interred This Afternoon," April 2, 1885.

Chapter 3

35. Johnston, *Memorial History of Louisville*, 627.

36. *Louisville Courier*, "Deaths of a Sabbath: David Frantz Sr. Succumbs to Paralysis at an Advanced Age," September 14, 1891.

37. *Louisville Courier-Journal*, "David Frantz Will: The Wealthy Tanner Distributes His Estate Among His Children," September 22, 1891.

38. Johnston, *Memorial History of Louisville*, 569.

39. *Louisville Courier-Journal*, "Will Pay Out, George Frantz's Embarrassment Temporary," February 2, 1902.

40. Ibid., "Onetime Showcase in Crescent Hill Stripped of Treasures, Put on Sale," December 8, 1959.

Chapter 4

41. Ibid., "Not Guilty of Neglect: The Coroner's Jury Attaches No Blame to Frank A. Menne & Co.," December 15, 1891.
42. Ibid., "$900,000: What Menne Gets in Cash and Stock," September 11, 1902.
43. Ibid., "Fire Wrecks Box Factory: F.A. Menne Candy Company Suffers $30,000 Loss," March 13, 1915.
44. Ibid., "New Factory Is Projected: $1,000,000 Candy Plant Is Assured by Shipping and Labor Advantages: Work Begins January 1," August 19, 1920.
45. Ibid., "Frank A. Menne: 64, Dies at Home: Was Candy Manufacturer for Forty Years," February 15, 1922.
46. Ibid., "Frank A. Menne Leaves $500,000: Candy Manufacturer's Widow Gets Estate: To Go to Children at Her Death," February 22, 1922.

Chapter 5

47. Ibid., "His Ledger Closed: Ripe in Years and Honor, John P. Morton Passes Peacefully Away," July 20, 1889.
48. Ibid., "John P. Morton & Company," September 30, 1867.
49. Kleber, *Encyclopedia of Louisville*, 628.
50. *Louisville Courier-Journal*, "His Ledger Closed."
51. Ibid.

Chapter 6

52. Ibid., "Summons: Comes to One of Louisville's Best Citizens: R.A. Robinson Passes Away," December 10, 1897.
53. Ibid.
54. Ibid.
55. Ibid.
56. Ibid.
57. Johnston, *Memorial History of Louisville*, 431.
58. *Louisville Courier-Journal*, "Half an Hour Between the Deaths of John A. Carter and John M. Robinson Yesterday," March 17, 1894.
59. Johnston, *Memorial History of Louisville*, 431–32.

Chapter 7

60. Allison, *City of Louisville and a Glimpse of Kentucky*, 82.

61. *Louisville Courier-Journal*, "A Sad Calamity: The Deplorable Results of the Thrilling Elevator Accident at McKnight's, Three Weeks Ago: Captain W.C. Hite, the Well Known Steamboat Man, Dies of His Injuries," December 7, 1882.

62. *Louisville Courier-Journal*, "The Death of William C. Hite," December 8, 1882.

63. Ibid., "A Sad Calamity," December 7, 1882.

64. Ibid., "Death Comes to Captain Hite: Last of the Prominent Louisville River Men," July 3, 1908.

65. Allison, *City of Louisville and a Glimpse of Kentucky*, 82.

Chapter 8

66. *Louisville Courier-Journal*, "'Mike' Muldoon: Widely Known Citizen's Long Career Ended by Death," April 27, 1911.

67. Allison, *City of Louisville and a Glimpse of Kentucky*, 127.

68. Ibid.

69. Ibid.

Chapter 9

70. *Louisville Courier-Journal*, "W.B. Belknap Dead: The Passing Away of a Leading Figure in Louisville's Business Life," February 25, 1889.

71. Ibid.

72. Ibid.

73. Ibid.

74. Ibid.; Kleber, *Encyclopedia of Louisville*, 82.

75. *Louisville Courier-Journal*, "William R. Belknap Passes Away: End at Midnight with Many of Family Near," June 2, 1914.

76. Kleber, *Encyclopedia of Louisville*, 82.

77. Ibid.

78. *Louisville Courier-Journal*, "Death Relives Long Suffering: Col. Morris B. Belknap Dies of Pernicious Anemia," April 14, 1910.

79. Ibid.

80. Ibid.
81. Ibid.
82. Ibid.
83. Kleber, *Encyclopedia of Louisville*, 83.

Chapter 10

84. *Louisville Courier-Journal*, "Full of Years: Dennis Long, the Veteran Manufacturer, Gathered to His Fathers," October 8, 1893.
85. Ibid.
86. Ibid., "Dennis Long & Co.; Union Pipe Works, Louisville Pipe Foundry, Union Foundry and Columbus Pipe Works," November 16, 1870.
87. Ibid., "From the Cathedral: Burial of the Late Dennis Long with Impressive Ceremonies," October 10, 1893.
88. Ibid.

Chapter 11

89. Ibid., "A Life Rounded, Mr. Benjamin F. Avery Breathes His Last Yesterday Morning," March 4, 1885; *History of the Ohio Falls Cities and Their Counties*, vol. 1, 547.
90. Ibid.
91. Ibid.
92. Ibid.
93. Allison, *City of Louisville and a Glimpse of Kentucky*, 84.
94. Ibid.
95. Kleber, *Encyclopedia of Louisville*, 56.
96. Sweetser, *King's Handbook of the United States*, 290.
97. Allison, *City of Louisville and a Glimpse of Kentucky*, 84.
98. *Louisville Courier-Journal*, "A Life Rounded."
99. Falk, *Louisville Remembered*.

Chapter 12

100. Kleber, *Encyclopedia of Louisville*, 210.
101. *Louisville Courier-Journal*, "An Invention, by Gum! Louisville: Chemist Launched Sweets to Chew," February 5, 1977.

102. Jack Parks, "Chewing Gum Is Louisville's Idea," *Louisville Courier-Journal*, June 18, 1939.

103. Ibid.; *Louisville Courier-Journal*, "An Invention, by Gum!"

104. Parks, "Chewing Gum Is Louisville's Idea."

105. Ibid.

106. *Louisville Courier-Journal*, "Taffy Tolu's Creator Dies: John Colgan Was First Man to Make Chewing Gum: Bright's Disease Brings End to National Figure," February 2, 1916.

Chapter 13

107. Ibid., "Death of H.D. Newcomb," August 19, 1874.

108. Ibid.

109. Ibid.

110. Johnston, *Memorial History of Louisville*, 474.

111. Ibid.

112. Ibid.

113. Ibid.

114. *Louisville Courier-Journal*, "The Newcomb Estate: Tragic Chapters in the History of a Most Respectable Family," March 13, 1875.

115. Ibid., "The Newcomb Case: Petition to Strike the Suit from the Records of the Court," March 28, 1875.

116. Ibid., "A Great Auction: Sale Last Week of the Late H.D. Newcomb's Residence and Contents," December 2, 1877.

117. Ibid., "Victor Newcomb Loses Contest: Court of Appeals Upholds H.D. Newcomb's Will," March 26, 1908.

118. Ibid., "H.V. Newcomb Dies Suddenly: Former Louisville Man Succumbs to Heart Trouble," November 4, 1911.

119. Ibid., "Fighting: For the Possession of His Millions: Victor Newcomb Appeals: To Courts for Discharge of the Lunacy Committee: Son and Mother Oppose," November 16, 1900.

120. Ibid., "H.V. Newcomb Dies Suddenly."

Chapter 14

121. Johnston, *Memorial History of Louisville*, 410–11.

122. *Louisville Courier-Journal*, "Gone to Rest: The Death of Mr. Andrew Graham: At One Time the Largest Tobacco Buyer of the City: Occurs at Brandenburg, The Funeral Today," November 16, 1884.

123. Ibid., "To Sleep at Cave Hill: The Funeral of the Late Andrew Graham Takes Place at Warren Memorial Church," November 18, 1884.

Chapter 15

124. Johnston, *Memorial History of Louisville*, 428–29.

125. *Louisville Courier-Journal*, "Louisville Loss: A Representative Merchant and Valued Citizen Passes Away, Thomas L. Jefferson," March 23, 1884.

126. Ibid., "He Rests: The Funeral of Mr. Thomas L. Jefferson, Takes Place on the Broadway Methodist Church with Impressive Ceremonies," March 25, 1884.

Chapter 16

127. Kleber, *Encyclopedia of Louisville*, 453.

128. *Louisville Courier-Journal*, "Paul Jones: Death Comes Suddenly to the Wealthy Distiller," February 24, 1895.

129. Ibid., "Paul Jones Funeral: Remains Deposited in a Vault in Cave Hill," February 27, 1895.

130. Reigler, *Kentucky Bourbon Country*, 117.

Chapter 17

131. Foster, *Civil War Cards*.

132. *Louisville Courier-Journal*, "Dr. Norvin Green Dying: President of the Western Union Entering the Dark Valley," February 12, 1893.

133. Bowen, *History and Battlefields of the Civil War*, 292–93.

134. Faust, *Historical Times Illustrated Encyclopedia of the Civil War*, 745.

135. *Louisville Courier-Journal*, "Dr. Norvin Green Dying."

Chapter 18

136. Johnston, *Memorial History of Louisville*, 587.
137. Ibid.
138. Ibid., 588.
139. Ibid.
140. *Louisville Courier-Journal*, "Major John Hess Leathers, Warrior, Patriot, Laid to Rest as Bugle Blows Taps at Grave in Cave Hill Cemetery," July 1, 1923.

Chapter 19

141. Ibid., "Well Known Citizens: Mr. James Bridgeford," July 20, 1884.
142. Ibid., "From Christ Church: The Funeral of the Late James Bridgeford to Occur This Morning," July 14, 1889.
143. Ibid., "Mr. Bridgeford's Burial: Last Solemn Service Over the Remains of a Distinguished Citizen," July 15, 1889.
144. Ibid., "Death of James Bridgeford Jr.," June 12, 1881.
145. Ibid., "James Bridgeford's Will: He Leaves an Estate Worth Nearly Half a Million Dollars to His Wife and Children," August 13, 1889.

Chapter 20

146. Ibid., "Loss to City: Business Men Pay Tribute to Dead Financier," July 9, 1912.
147. Ibid.

Chapter 21

148. *Louisville Daily Courier*, article no. 10 regarding J.B. Wilder & Co.'s Drug Store, August 28, 1852.
149. *Louisville Courier-Journal*, "Death of J.B. Wilder, Sudden and Expected Demise of the Wealthy Drug Merchant," May 17, 1888.
150. Ibid.
151. Ibid., "J.B. Wilder's Will: Full Text of the Holographic Document Disposing of $1,138,000," May 24, 1888.
152. Ibid., "Death of J.B. Wilder."

Chapter 22

153. Ibid., "Dr. John Bull: Sudden Death of the Well-Known Druggist Yesterday," April 27, 1875; Kleber, *Encyclopedia of Louisville*, 141.
154. *Louisville Daily Courier*, "Removal of Dr. John Bull to New York," July 29, 1854.
155. Ibid.
156. Ibid.
157. *Dr. John Bull's United States Almanac*, 1856, United States National Library of Medicine.
158. Kleber, *Encyclopedia of Louisville*, 141.
159. Ibid.

Chapter 23

160. Johnston, *Memorial History of Louisville*, 570–72.
161. Ibid.
162. Ibid.
163. Ibid.
164. Ibid.
165. Ibid.
166. *Louisville Courier-Journal*, "In Death: Body of Capt. Daniel G. Parr Is Found: Heart Attack Proves Fatal," January 20, 1904; Johnston, *Memorial History of Louisville*, 570–72.
167. *Louisville Courier-Journal*, "In Death: Body of Capt. Daniel G. Parr."
168. Ibid.; Johnston, *Memorial History of Louisville*, 570–72.
169. Williams, *My Old Confederate Home*, 52.
170. *Louisville Courier-Journal*, "Captain Parr's Gift: Property Valued at $20,000 Deeded to Baptists in the City of Petoskey, A Church to Be Erected in Memory of the Louisville Capitalist's Wife," August 16, 1901.
171. Ibid., "In Death: Body of Capt. Daniel G. Parr."
172. Thomas, *Cave Hill Cemetery*, 96.

Chapter 24

173. *Louisville Courier-Journal*, "How They Began Life: Successful Bank Presidents and How They Got Their Starts," April 27, 1890.

174. Ibid., "Death's Call: Comes to Mr. Jacob Hopewell Lindenberger," January 23, 1900.

175. Ibid.

176. Ibid., "Sold at a Sacrifice: Sale of the Newcomb-Buchanan Distilleries for an Aggregate Price of $145,600," March 6, 1885.

177. Ibid.

178. Ibid., "J.H. Lindenberger's Estate," January 30, 1900.

Chapter 25

179. Ibid., "Rural Schools Father Is Dead: John B. McFerran's Notable Career of Philanthropy Is Ended," February 20, 1920.

180. Ibid., "Cudahy Coming: The Great Chicago Packer Certain to Locate Here, Messrs McFerran, Shallcross and Company Are to Retire," December 12, 1891.

181. Ibid.

182. Ibid.

183. Ibid., "Simple Services: At Fourth Avenue Baptist Cornerstone Laying Original Gift by John B. McFerran," November 23, 1909.

184. Ibid.

185. Ibid., "400 Attend Dedication of John B. McFerran School," December 9, 1915.

186. Ibid., "Five Soldier Grandsons of John B. McFerran," November 3, 1919.

187. Ibid., "$350,000 Goes to 4 Children: Will of John Byrd McFerran Shows $100,000 Given to Charities and Churches," March 20, 1920.

BIBLIOGRAPHY

Allison, Young. *The City of Louisville and a Glimpse of Kentucky, Published Under the Direction of the Committee of Industrial and Commercial Improvement of the Louisville Board of Trade*. N.p., 1887.

Bowen, John. *The History and Battlefields of the Civil War*. N.p.: Wellfleet Press, 1991.

Cashman, Scott. *America in the Gilded Age: From the Death of Lincoln to the Rise of Theodore Roosevelt*. New York: New York University Press, 1984.

Elstner, J.M. *The Industries of Louisville, Kentucky and of New Albany, Indiana: Their Natural, Mercantile, Manufacturing, Financial, and Commercial Resource and Facilities*. Louisville, KY: J.M. Elstner Publishers, 1887.

Falk, Gary. *Made in Louisville: Industrial Achievements of a Great American City from Its Founding to the Year 2013*. Shepherdsville, KY: Publishers Printing House, 2013.

Faust, Patricia. *Historical Times Illustrated Encyclopedia of the Civil War*. N.p.: Perennial, 1991.

Foster, Stephen. *Civil War Cards*. Boxed Set, Atlas Edition, 1995.

The History of the Ohio Falls Cities and Their Counties: General History. Vol. 1 Cleveland, OH: L.A. Williams & Company, 1882.

Huckelbridge, Dane. *Bourbon: A History of the American Spirit*. New York: HarperCollins Publishers, 2014.

Johnston, J. Stoddard. *Memorial History of Louisville from Its First Settlement to the Year 1896*. Vol. 1. Chicago: American Biographical Publishing Company, 1896.

Kleber, John, ed. *The Encyclopedia of Louisville*. Lexington: University Press of Kentucky, 2001.

Klein, Maury. *History of the Louisville & Nashville Railroad*. New York: Macmillan Company, 1972.

Louisville: Nineteen Hundred and Five. Louisville, KY Commercial Club, n.d.

Reigler, Susan. *Kentucky Bourbon Country: The Essential Travel Guide*. Lexington: University Press of Kentucky, 2016.

Riebel, R.C. *Louisville Panorama: A Visual History of Louisville, Liberty National Bank and Trust Company*. Louisville, KY, 1954.

Sweetser, Moses Foster. *King's Handbook of the United States*. Buffalo, NY: Moses King Corporation Publishers, 1891–92.

Thomas, Samuel. *Cave Hill Cemetery: A Pictorial Guide and Its History*. Louisville, KY: Cave Hill Cemetery Company, 1985.

Williams, Rusty. *My Old Confederate Home: A Respectable Place for Civil War Veterans*. Lexington: University Press of Kentucky, 2010.

Yater, George. *Two Hundred Years at the Falls of the Ohio: A History of Louisville and Jefferson County*. Louisville, KY: Heritage Corporation of Louisville and Jefferson County, 1979.

NEWSPAPERS

Louisville Courier-Journal.

ABOUT THE AUTHOR

Bryan Bush was born in 1966 in Louisville, Kentucky, and has been a native of that city ever since. He has been a member of many different Civil War historical preservation societies; has consulted for movie companies and other authors; coordinated with museums on displays of various museum articles and artifacts; written for magazines such as *Kentucky Civil War Magazine*, *North/South Trader* and *Back Home in Kentucky*; and worked for many different historical sites. Bush has been a Civil War reenactor for fourteen years, portraying an artillerist. For five years, Bush was on the board of directors and curator for the Old Bardstown Civil War Museum and Village: The Battles of the Western Theater Museum in Bardstown, Kentucky. This is Bryan's fourth title with The History Press.

Visit us at
www.historypress.com